THIS BOOK IS DEDICATED TO MY WIFE, TRACEY

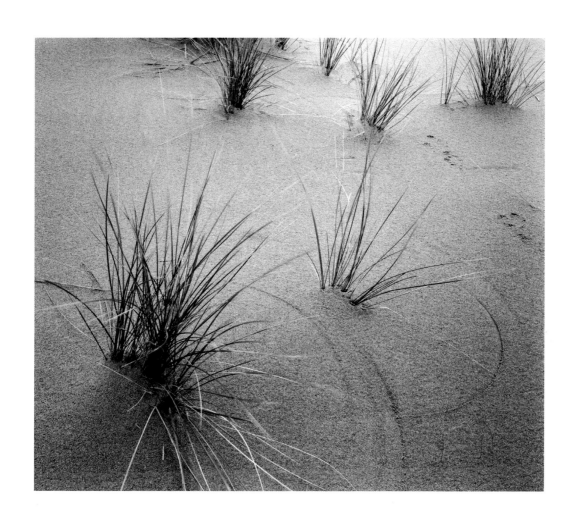

ELEMENTS

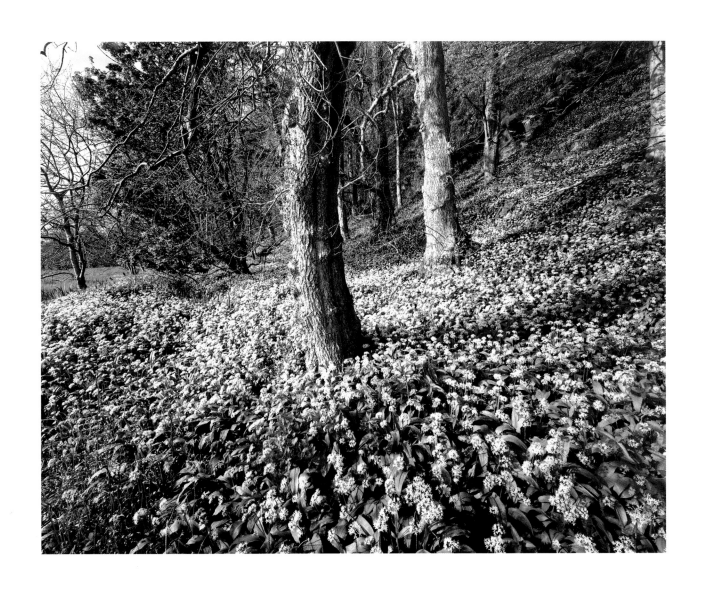

ELEMENTS
the landscape of scotland

PHOTOGRAPHS BY CRAIG MCMASTER

FOREWORD BY GEORGE WYLLIE

ESSAY ON THE LAND BY THE JOHN MUIR TRUST

JOHN
MUIR
TRUST

THE BRUSH AND TOOL MARKS of a painter or sculptor indicate the human touch of their art and offer evidence of the physical energy applied to their making. What then marks the creative energy of a photographer? To know that it surely exists, contemplate the work of Craig McMaster.

An intentional and well-considered feeling for creating an energised photograph marks his work. The perception of a meaningful image begins within his mind and inward eye. The concept is captured by the technology of a clever lens then meticulously processed. The energy remains and shines through the artwork.

With his eyes lifted towards the cosmos, he is a serious thinker with a genuine appreciation of the earth-bound space he occupies. Like a modern shaman he randomises amongst the rawness of dear old Scotland and celebrates its magic and wild places. He respects and records its stones, landscapes, mountains, rivers, clouds and beyond. His photographic emphasis on the eternal influences of our being helps us visualise the soul of our planetary place.

None of this could happen without physical stamina, for mountain tops and rugged wild places are not easily approached. His photographs clearly indicate that he will travel anywhere for the right sight line. He will tolerate the mischief of the clouds, tides and fickle weather to ensure the right moment for opening his shutter. In a high-speed world we indeed have a man as unhurried as the seasons.

I am suggesting that to create a complete artwork, the initial conceptual instructions from the mind require a secondary physical response for the realisation of the work. Having identified the required energies of the 'body' and 'mind' within the photographs, there is still the subliminal presence of the third human energy of 'spirit'. The equilibrium of 'body'—'mind'—'spirit' is now complete; but how can a photograph contain the spirit?

The answer is easy, for Craig McMaster is dedicated to exploring the nuances of his native land. With his mind's eye keenly observing the pictorial generosity of its nature in all its moods and glories, it would be impossible for his art not to absorb the gift of spirit that the crystal air of Scotland offers to him and us.

George Wyllie

portrait by Alan Jones

[TECHNICAL NOTE] The majority of photographs within this book were made using a Linhof Technikardan camera. This is a large-format camera, which produces negatives of 5x4 inches in size. This large-format negative size enables me to capture a great deal of detail within a scene for the subsequent production of a final print. I use a variety of Schnieder Super Angulon lenses, which can produce incredibly sharp and precise images.

In addition to making 5x4-inch negatives, I often use a medium-format film holder (6x7 cm) which gives me the versatility of 120 roll film. This option provides me with 10 frames on 120 format rather than a single image per sheet of 5x4 film. Most negatives were made using either Ilford Delta 100 or Kodak Technical Pan, both of which I prefer due to the fine grain structure of the films.

Colour filters, normally red or orange, are sometimes used on the camera lens to increase the blackness of skies or for other effects. A polarising filter is sometimes used. The weight of the camera, tripod and associated equipment is a constant problem especially when working in mountainous areas. I normally pack the equipment in a North Face mountaineering rucksack, which I find best suits my needs.

Working with a large-format camera in the field is a slow and methodical process. It normally takes about 10–15 minutes to set up and focus the camera before an exposure can be made. Image composition and focusing is done under a dark cloth on a ground glass screen with the image upside down and back to front. This is an unhurried yet complex approach to landscape photography that I find helps to concentrate my mind when making an image.

I am quickly abandoning conventional darkroom printing for a modern digital darkroom process. Conventional negatives are still produced but these are then scanned and converted to digital files. Traditional darkroom manipulation of the image is now being replaced by computer applications. I still employ the same photographic techniques of dodging, burning, cropping etc but this is done digitally rather than chemically in a darkroom. Final prints are made from the digital files to archival standards.

THE PHILOSOPHER ARISTOTLE suggested that the world was made of the four elements: earth, fire, air and water. Our understanding of the universe has increased greatly since the time of Aristotle but for me this simplistic description sufficiently defines the fabric of the primordial Scottish landscape. Scotland is an ancient land historically shaped by the endless energies of volcanic fires, glacial ice flows and oceanic storms—an elemental landscape indeed.

I am inspired by the rugged and enigmatic beauty of Scotland's wild places and love to explore its remote mountains, coastlines and woodlands. It is this inspiration and feeling of wonder I attempt to convey through my photographs. I do not set out to produce a precise mechanical photographic reproduction of the scene before the camera; instead I attempt to capture and convey the essence of the natural wonder which initially inspired me. I consider the simple yet powerful medium of black and white photography to be the most suitable method of capturing and conveying this essence and inspiration from nature. Colour is not always necessary. Indeed, the removal of colour from a scene in nature forces us to consider only its fundamental elements and its simplicity.

The removal of colour from a familiar scene instantly introduces an abstract quality to the image—it forces us to use our imagination. In a black and white photograph, familiar scenes in nature are transformed into an elegant world of shape, form, texture and light where our imagination is permitted to roam.

The technical stages involved in the production of black and white photographs allow the photographer greater control, leading to truly expressive final images. Normally this control is achieved through making negatives, film processing and final printing. It is through these technical processes that I attempt to capture and convey, through expressive prints, my true inspiration from the natural world.

For many years I admired and respected the fine work of several American landscape photographers. I was convinced that the wild and rugged landscape of Scotland also deserved to be captured and conveyed through the power and beauty of black and white photography as shown by these pioneering artists. It was this initial inspiration which ignited my desire to produce a collection of black and white photographs of the Scottish landscape and eventually led to the publication of this book.

My desire to develop this collection of photographs has taken me to some of Scotland's most remote and wild places in the pursuit of images which truly express the way I see the world. I have found myself alone on the summits of Scotland's highest mountains at sunrise or on desolate Hebridean beaches watching storm clouds rise from the ocean. It is difficult not to feel a sense of awe and humility when faced with the raw power and beauty of nature. However, for me, a landscape photograph does not necessarily require a wild seascape or mountain range; a landscape can also be defined by the smallest of details. Moss-covered tree branches, waves on a beach or ferns on a forest floor all convey a sense of place.

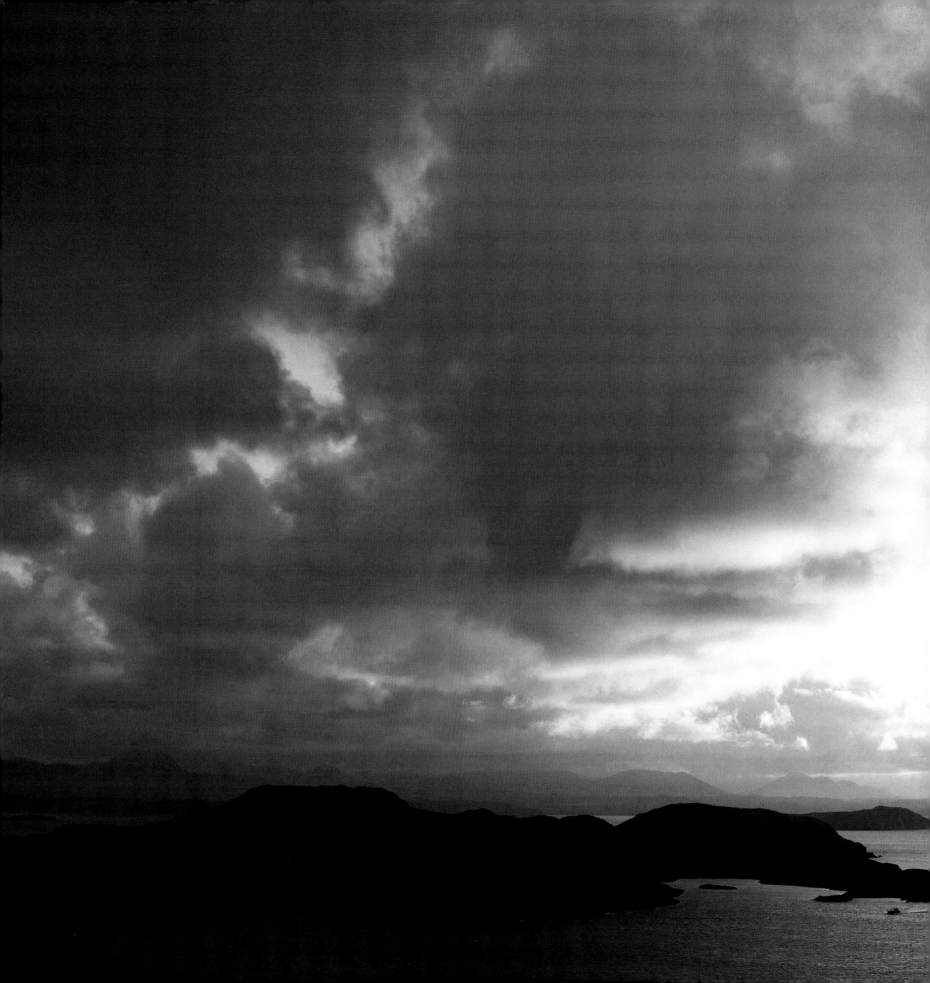

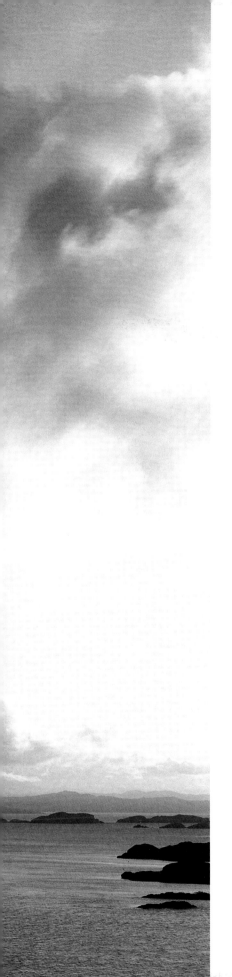

A good landscape photograph captures a unique moment in time, which will never be repeated. These special and fleeting moments occur when the balance of light, land and the seasons combine to produce a scene of outstanding beauty. The challenge for the landscape photographer is to be in position, ready to capture these moments when they occur. An intimate understanding of the land, the seasons and the weather is essential when hunting these moments in nature. I believe our ancestors possessed a similar understanding of the natural world and they used this to live in equilibrium with their surroundings. As people lost this understanding and relationship with the natural world, so we lost our respect for the environment in which we live.

The early environmentalists like John Muir and Ansel Adams sensed the impending conflicts between the development of our society and the preservation of our natural environment. They campaigned and spoke out for the preservation of wild places and worked to regenerate people's respect for the natural world. The task of protecting these wild places has been continued through the work of organisations such as the John Muir Trust and other environmental groups. Only through the continued efforts of such organisations can the character of Scotland's wildest places be preserved to inspire future generations.

Someone once told me that photographs are all about memories. The photographs that I present in this book are therefore my memories, which I now share with you. I felt inspired and happy to witness these special moments in nature. My respect for the natural order of our world has increased while making this collection of images. By sharing these moments and my experiences through the photographs, I hope in some small way to increase your respect for our world.

Craig McMaster

'Bathed in such beauty, watching the expressions ever varying on the faces of the mountains, watching the stars, which here have a glory that the lowlander never dreams of, watching the circling seasons, listening to songs of the waters and winds and birds, would be endless pleasure. And what glorious cloud-land I would see, storms and calms, a new heaven and a new earth every day'

[JOHN MUIR, SIERRA CLUB BULLETIN, JANUARY 1911]

an essay on the land by the John Muir Trust

[ALISON MCGACHY]

WHEN I FIRST LOOKED through this collection of images of some of Scotland's most remote and wild places I was struck by the sheer diversity of landscapes that inhabit this small land. The range of woodland, coast, heath and high mountains in this book could have been taken from several countries, or even continents.

That they all make up one country hints at a violent geological past to match the nation's turbulent human history. Scotland has been welded together by millions of years of tectonic drift, volcanic upheaval and glacial flow. The result is a breathtaking variety of habitats, wildlife and landscape.

Craig McMaster's photographs are a dramatic record of these landscapes as well as a tribute to the natural resources that help make Scotland so admired worldwide. He shows the architecture of the country's mountains and upland areas; even here, variations in rock type and erosion mark out different terrain. For example, his photographs contrast the volcanic eruptions that formed the rocky mountains of Glencoe with the much older sandstone of Torridon on the Highland edge.

These glens and straths support the peatlands of the far north, pinewoods and heather moorlands in the central and eastern Highlands and the Atlantic oakwoods to the west. Images of the remnants of ancient pine and birch forest in Glen Affric hint at how much of Scotland's landscape once looked when it was dominated by native woodland.

Craig's photographs also capture the dynamic rivers that link land and sea together with the distinct coastline of Scotland's eastern and western extremes. On the west coast, rich machair grasslands back onto fine shell beaches. On the east coast, the North Sea throws up huge silica sand dunes, stitched together by the long roots of marram grass.

The black and white photography does much more than simply record Scotland's different landscapes, it offers up an emotive response to wild open spaces. Craig strips the land down to its barest elements: sky, light, water and earth. Whether it is storm clouds above mountains, or the

spectral branches of a tree caught by a flash of sunlight, these pictures capture something both fleeting and eternal. Exploring these landscapes inspires wonder, awe and humility.

In our modern world, these images also carry a profound sense of melancholy. Across much of the British Isles the image of a single, coherent landscape has long since been shattered. Industrialisation and the relentless advance of man's urban jungle has fragmented natural habitats the world over.

Scotland is no exception. Look at the photographs in this book of open heath and moorland and the overall impression is of barrenness. This emptiness, heightened by the lack of people, is unnatural. Old Caledonia, once covered in dense forest, has long since been cut down by human intervention. The loss of tree cover has condemned much of the Highlands to poor, badly eroded soil that is only fit for heather and bracken. Less than one percent of the old native woodland remains.

As marked as these landscapes are, the past hundred years have had a far more damaging impact on our ecology than the previous four centuries of human history. Between 1940 and 1990, the area of land covered by buildings and transport corridors in Scotland increased by 36%. Over-fishing threatens our seas. The run-off of fertilisers from intensive farming pollutes our rivers. Over-grazing from deer and sheep damages our moorlands. The list of man-made toxins that are turning up in our food, our bodies and the natural environment grows unchecked.

The future holds yet deeper uncertainties. 2003 was the warmest year in Scotland since the Met Office first started recording temperatures on the mainland in 1861. It could be a freak year. However, this unusually warm weather does fall into a pattern of rapid global warming brought on by the build-up of greenhouse gases in the atmosphere.

If the predicted rise in temperature over the coming decades is borne out, the consequences for Scotland's landscapes could be devastating. A report by the British-Irish Council on the impact of global warming on Scotland's islands in July 2003 predicted that Orkney, Shetland and the Hebrides will be increasingly lashed by massive storms and rising seas. The report questioned the survival of rare species and the viability of these island communities by as early as 2080.

The answer is not to isolate the wilder areas of Scotland like specimens in a zoo, fence them in and revere them from afar. Humans are an essential part of the balance of life in the natural landscape. Portraits of the old crofting ways on the islands by photographers such as Werner Kissling in the 1930s and Paul Strand in the 1950s show a people's profound symmetry with the seasons and available resources.

Modern consumerism and a global economy blindly bent on profit has left this simple world far behind. Rather than acting as responsible guardians of the environment, 21st-century man is mining the earth and looting the seas. At current rates of consumption and population growth, the

human race will need the equivalent of three planets to support itself by 2050. We urgently need to find ways of balancing the demand for human development with the stress that this inevitably puts on the world's finite resources.

Answering this call to protect our fragile environment, the John Muir Trust was established. For 21 years it has been working tirelessly to save and conserve our wild land. The Trust takes its name from John Muir, the Scots-born American who was the first to call for practical action to safeguard and cherish the world's wild places. Since 1983, the John Muir Trust, guided by Muir's message to 'do something for wildness and make the mountains glad', has dedicated itself to making Muir's message a reality in the United Kingdom.

The Trust believes that sustainable conservation can only be achieved by recognising and understanding the special qualities of wild places and the many aspects which make up wild landscapes.

The John Muir Trust is:

• the country's strongest voice for wild land and the wilderness experience

• protecting seven key areas of wild land in Scotland through ownership and management

• helping communities become guardians of other areas of outstanding wild land—North Harris and Knoydart

• keeping Britain's highest mountain, Ben Nevis, wild and beautiful—with no future risk of hotels or railways

• working towards securing a safe future for the main ridge of the Cuillin on Skye through conservation and community ownership and management

• presenting a strong defence of one of Scotland's wildest areas by rigorously opposing plans for a hydro-electric scheme south west of Loch Maree

• restoring Schiehallion to its former glory by removing the ugly erosion scar of the path blighting this landmark mountain

• bringing back beautiful native woodlands—with all their birds, animals, flowers and other vegetation, insects, mosses and fungi—in Knoydart, Skye, Sandwood, Schiehallion and Glen Nevis

• winning hearts and minds for the cause of wild places by encouraging over 12,000 people to take part in the John Muir Award

• Giving people who love wild places a chance to 'put something back' through voluntary conservation work and other activities supporting the work of the Trust

In working to conserve the environment, the Trust does not have to be out of step with the harsh economic realities of modern times. Conserving and restoring the stunning landscape that has been so eloquently captured in this book is a genuine investment. These wild places draw visitors from around the world to climb, walk, watch wildlife or simply contemplate their peace and beauty. Carefully managed tourism, which already employs an estimated 8% of the workforce, could provide a lifeline to remote rural communities facing declining incomes from traditional livelihoods such as fishing.

Looking at the picture of standing stones on Arran, I wonder what remnants of the 21st century will catch a photographer's eye thousands of years from now. Will our archaeology be as graceful as the Machrie stones? Or will we leave behind a legacy of urban sprawl, pollution and habitat destruction?

John Muir died in 1914 and yet he had the vision to be calling for the protection of vast tracts of land before it was too late. One man made such a difference to the conservation movements in North America and across the world. I hope this message inspires you to take action.

The future of our environment is in our hands and Craig McMaster's photography shows us just how much we have to lose.

JOHN MUIR TRUST
41 COMMERCIAL STREET
EDINBURGH
EH6 6JD
T. 0131 554 0114
www.jmt.org

JOHN
MUIR
TRUST

I often wonder what man will do with the mountains—that is, with their utilizable, destructible garments.

Will he cut down all the trees to make ships and houses?

If so, what will be the final and far upshot?

Will human destructions like those of Nature—fire and flood and avalanche—work out a higher good, a finer beauty?

Will a better civilization come in accord with obvious nature, and all this wild beauty be set to human poetry and song?

Another universal outpouring of lava, or the coming of a glacial period, could scarce wipe out the flowers and shrubs more effectively than do sheep.

And what then is coming?

What is the human part of the mountains' destiny?

[JOHN MUIR, JOHN OF THE MOUNTAINS, AUGUST 1875]

HIGHLAND

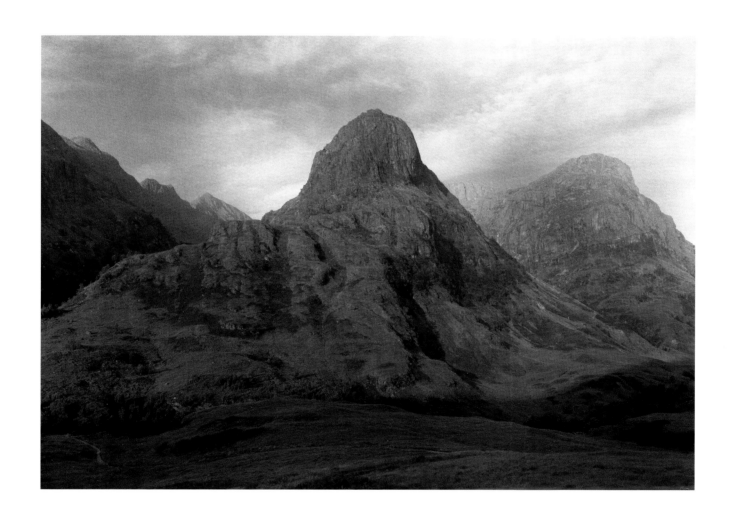

GEARR AONACH, GLENCOE

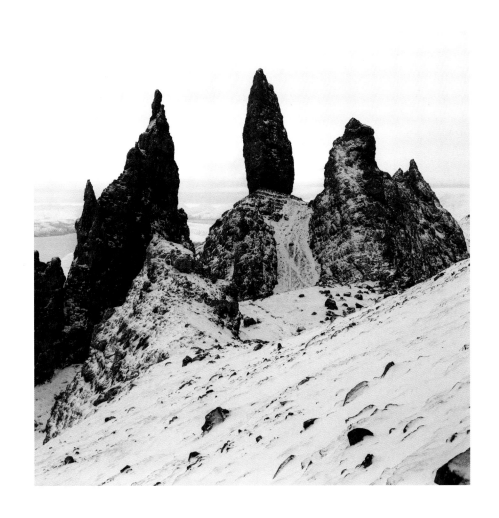

THE OLD MAN OF STORR, ISLE OF SKYE

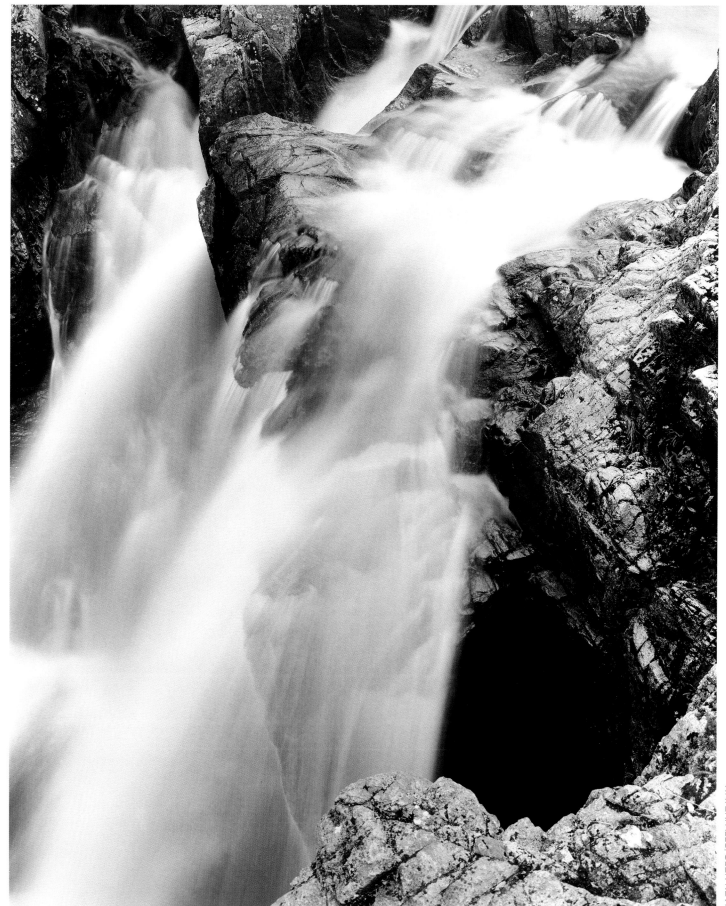

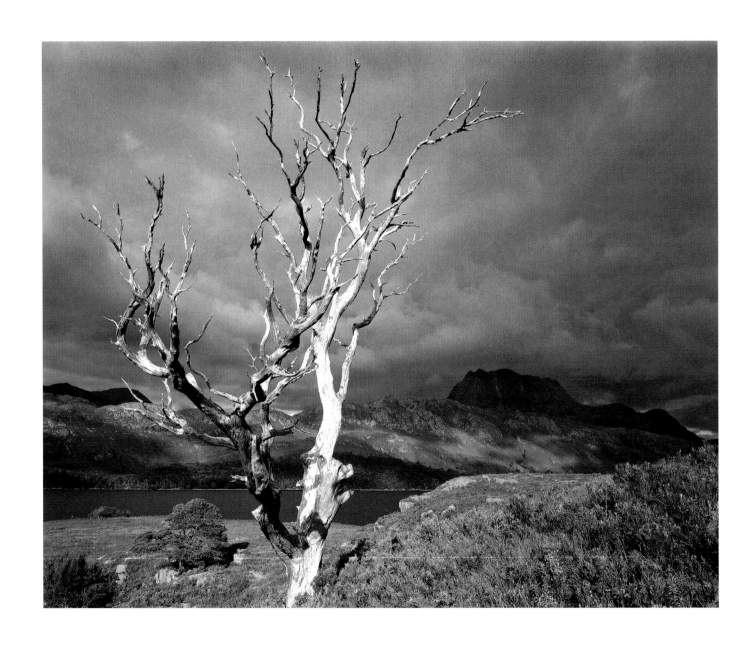

DEAD TREE AND LOCH MAREE, WESTER ROSS

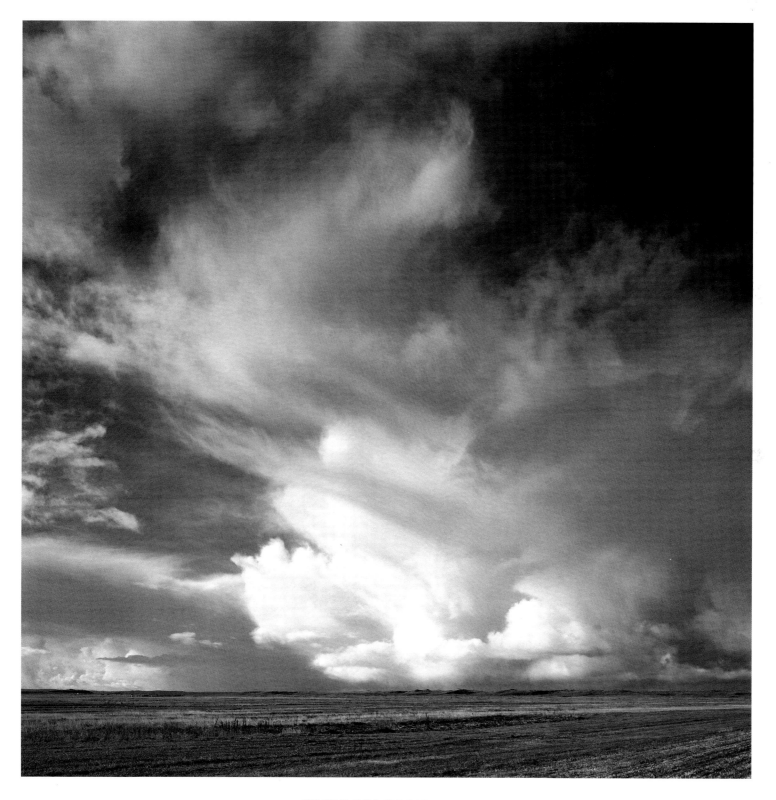

STORM CLOUDS, ISLE OF BERNERAY

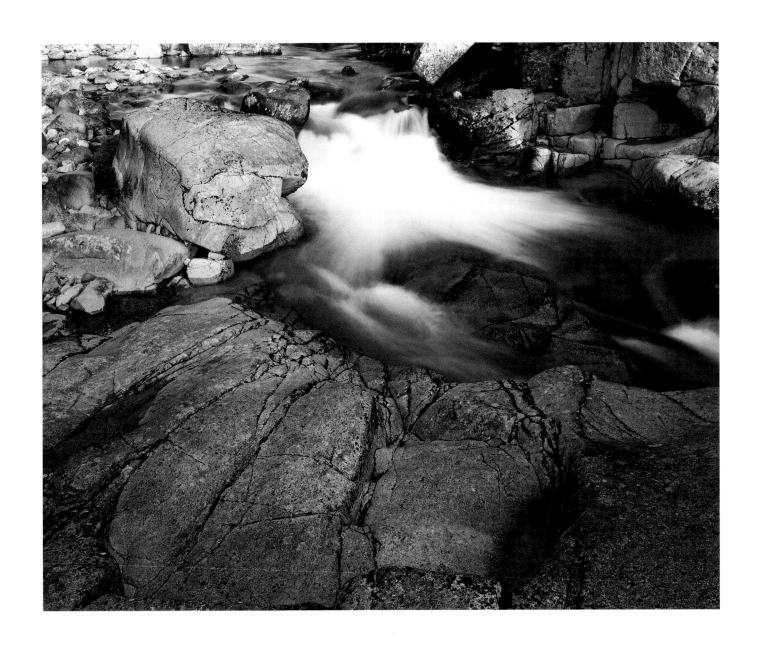

WATER DETAIL, GLENCOE

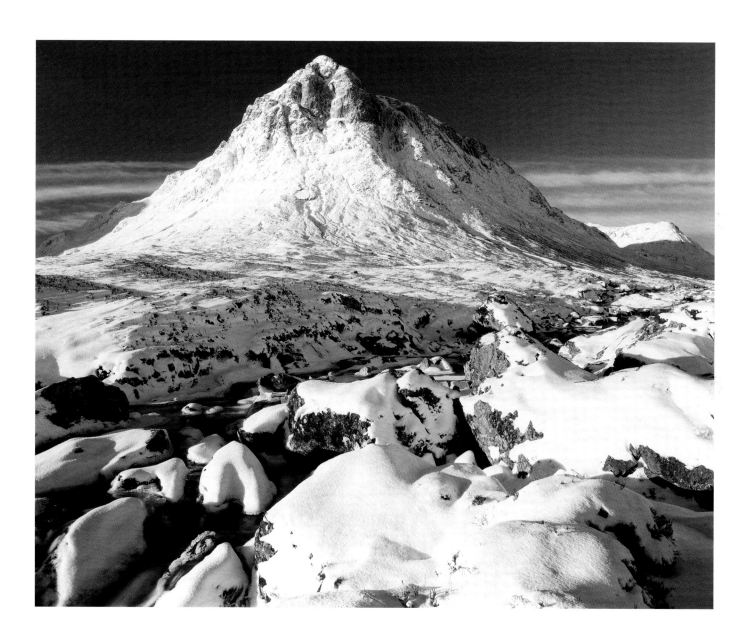

BUACHAILLE ETIVE MOR, GLENCOE

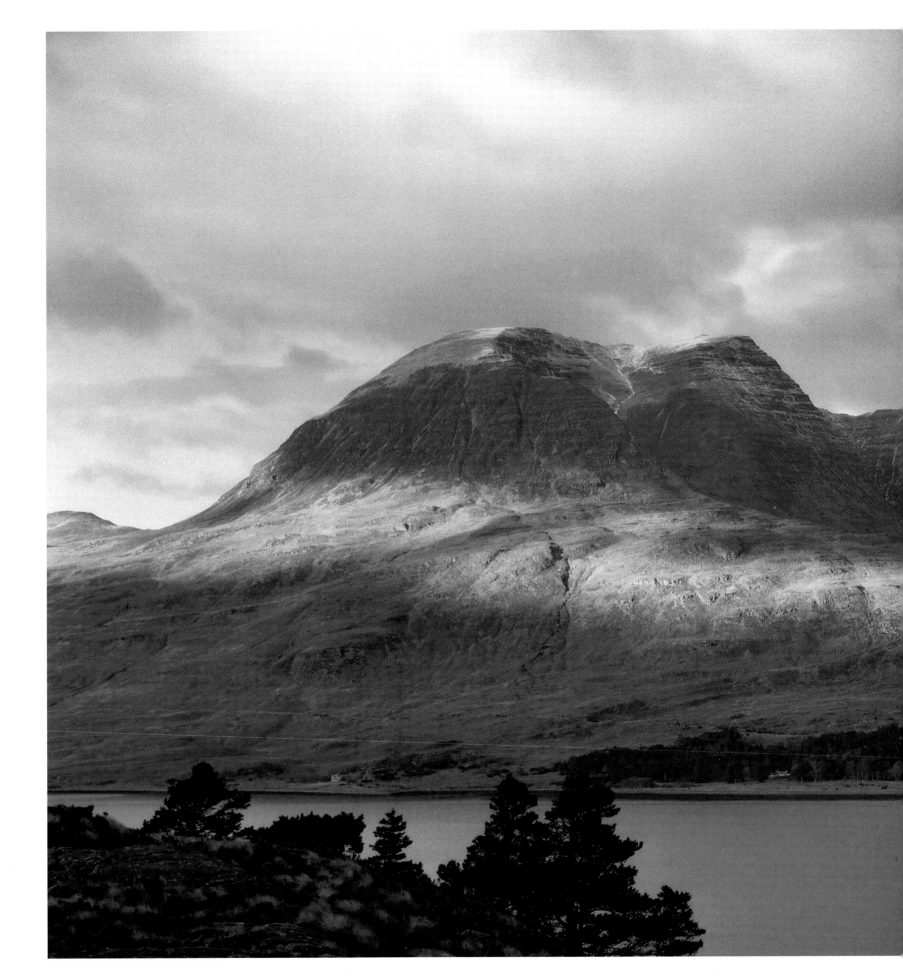

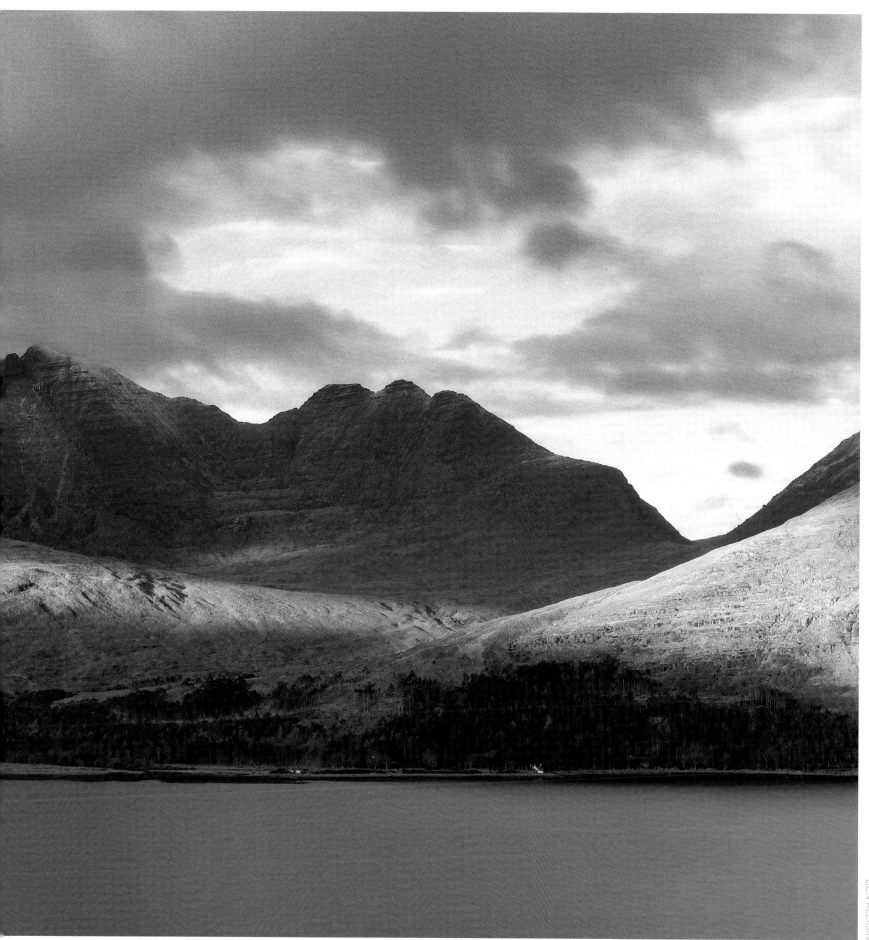

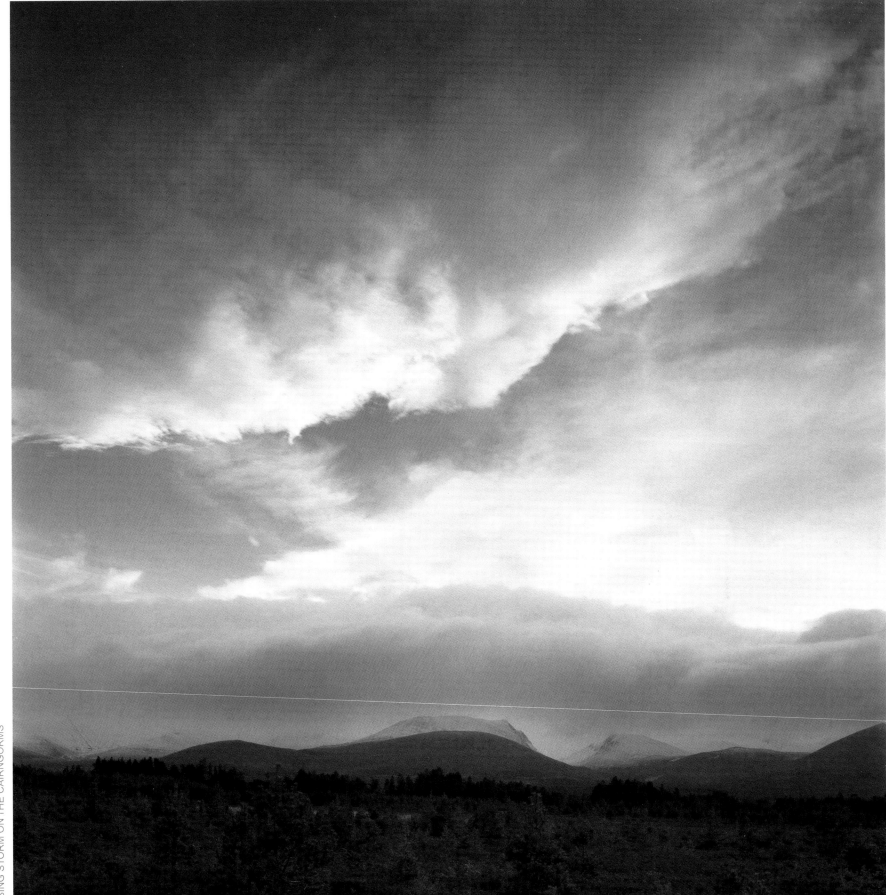

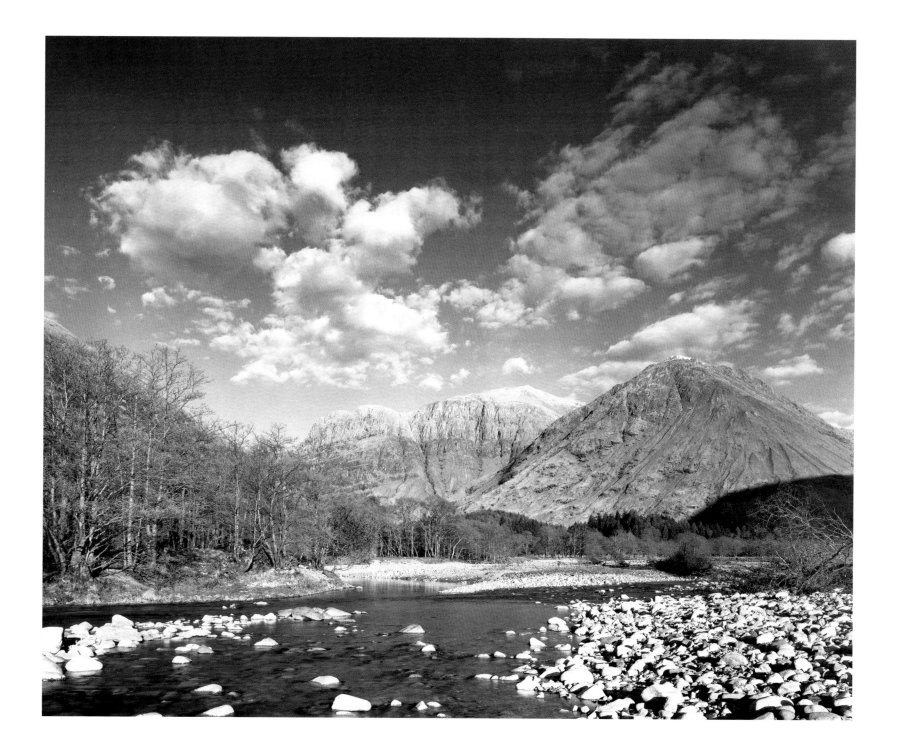

THE RIVER COE, GLENCOE

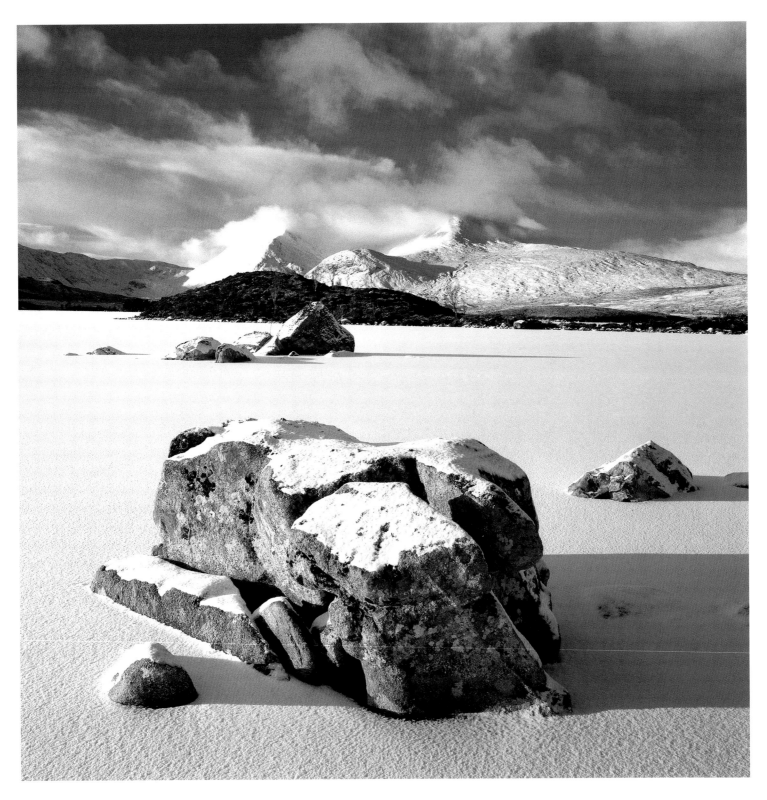

THE BLACK MOUNT AND LOCHAN NA H-ACHLAISE, RANNOCH MOOR

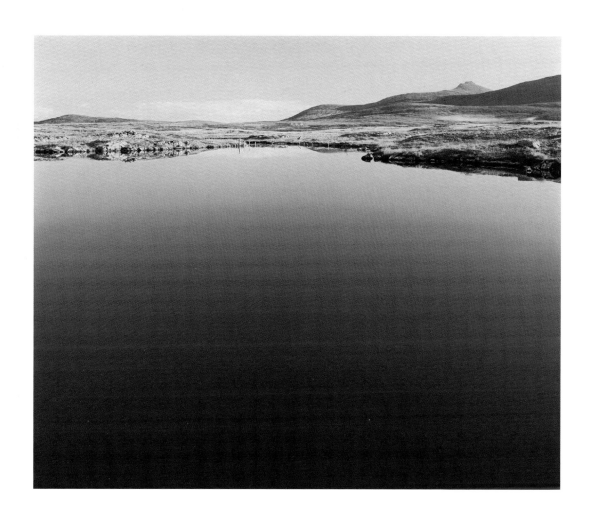

MOORLAND LOCHAN, ISLE OF SOUTH UIST

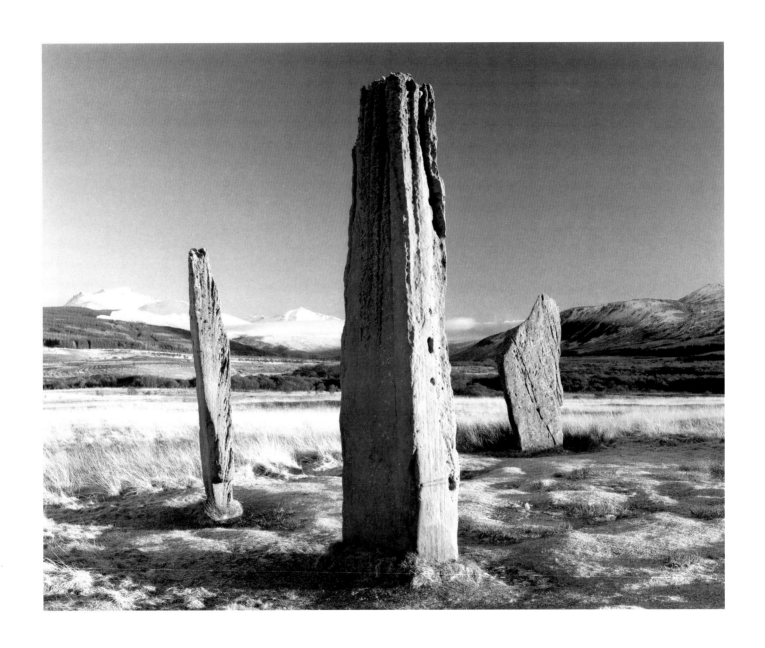

MACHRIE STONES, ISLE OF ARRAN

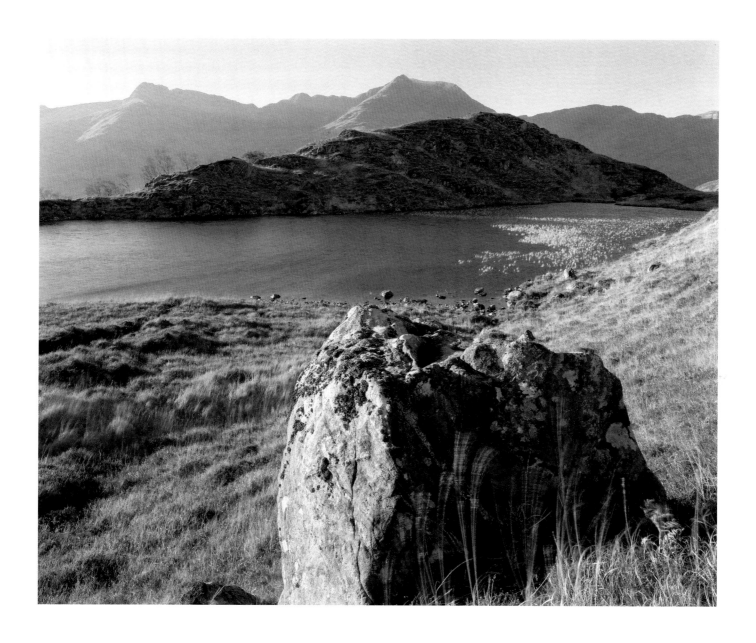

LADHAR BHEINN AND LOCHAN UAMHALT, KNOYDART

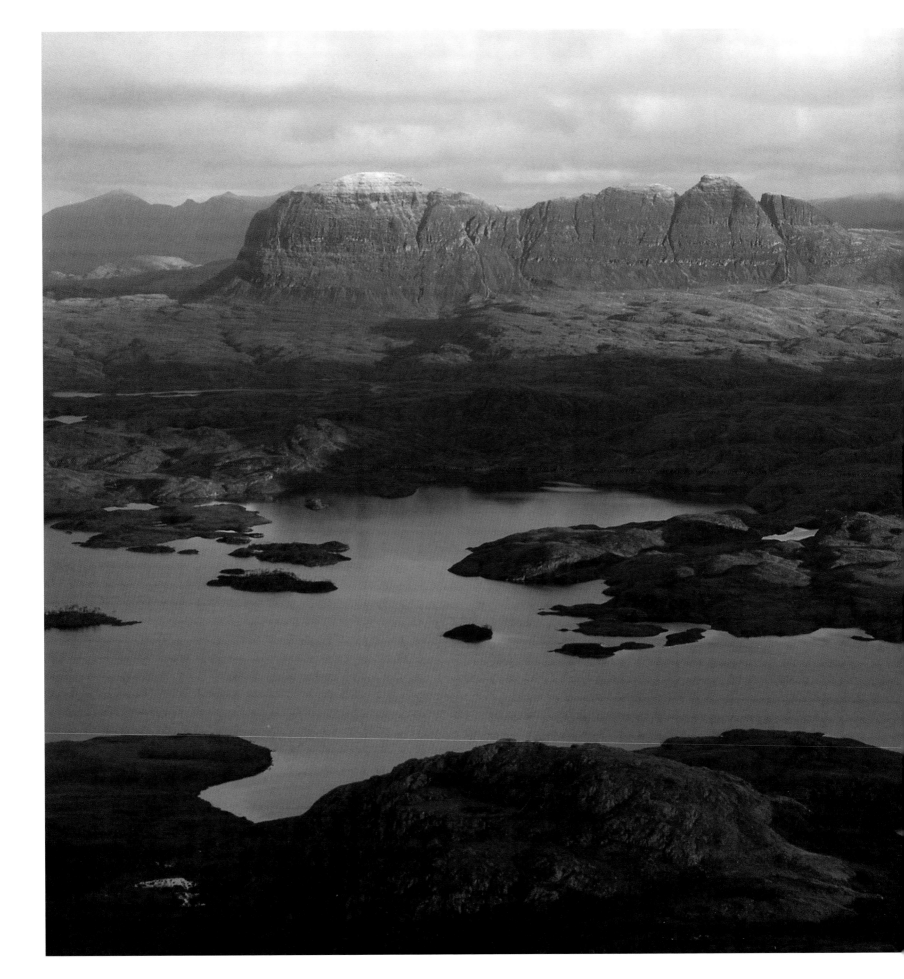

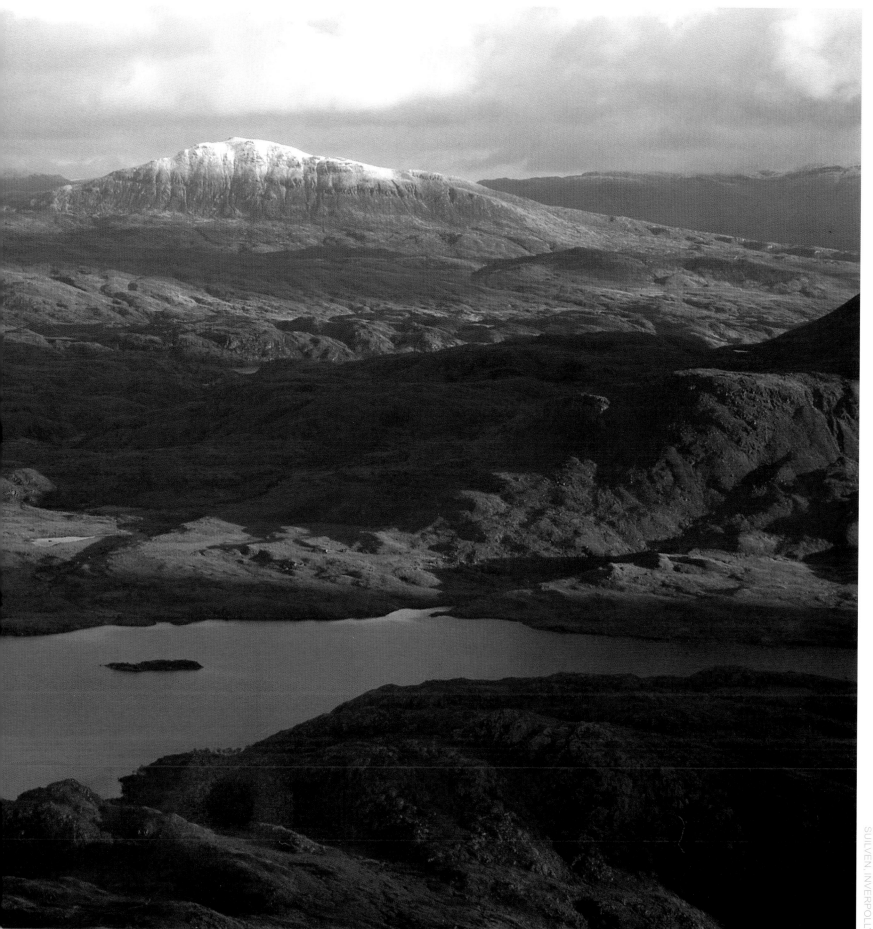

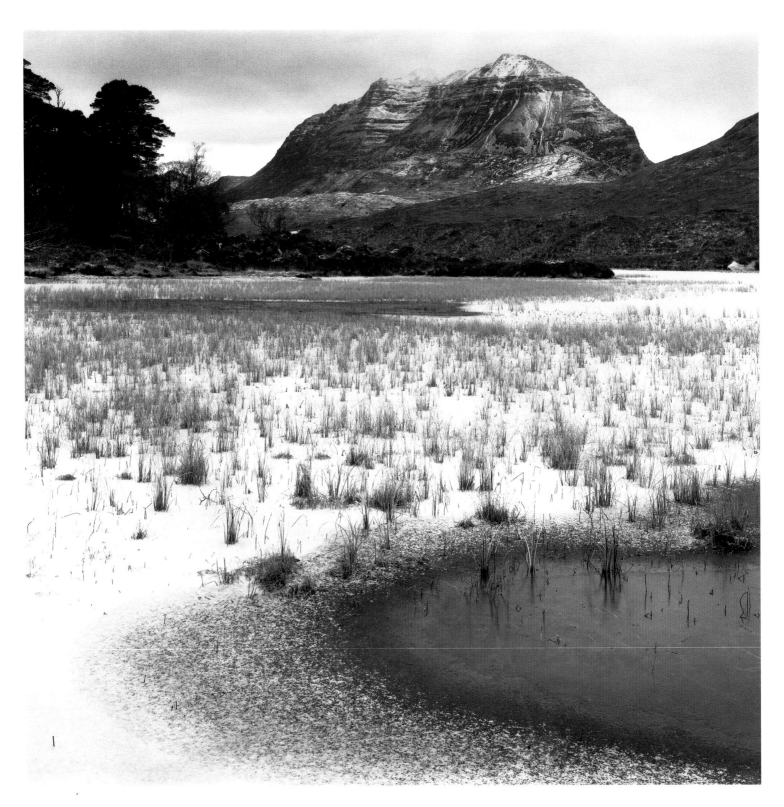

LIATHACH AND LOCH CLAIR, TORRIDON

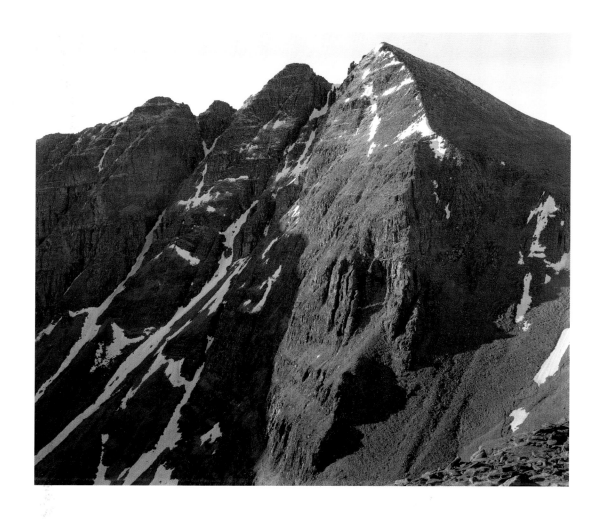

BIDEIN A' GHLAS THUILL, AN TEALLACH

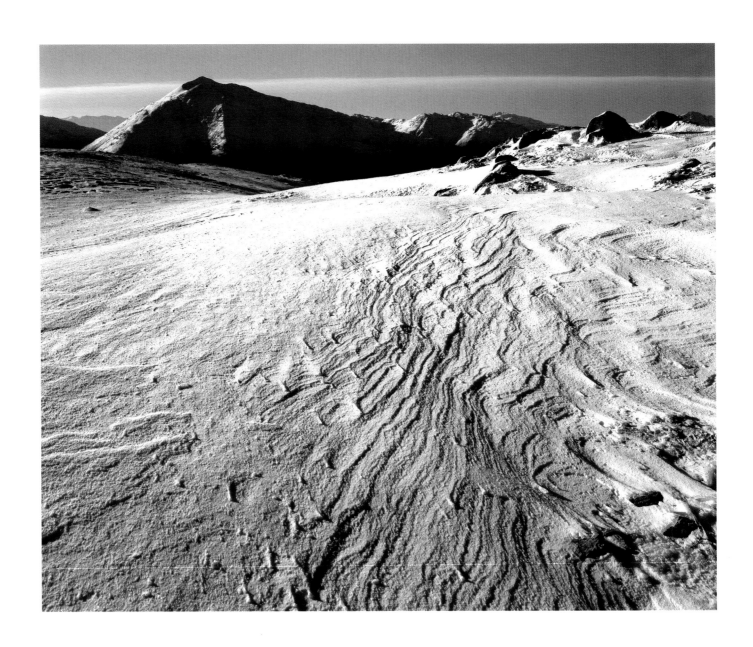

MEALL MOR AND ICE FORMATIONS, LOCH LEVEN

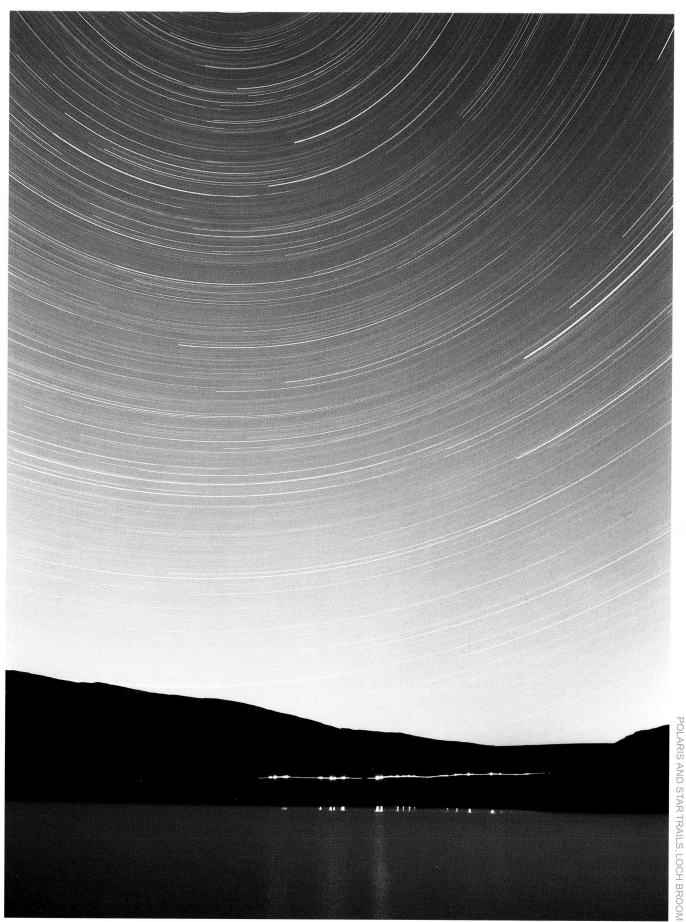

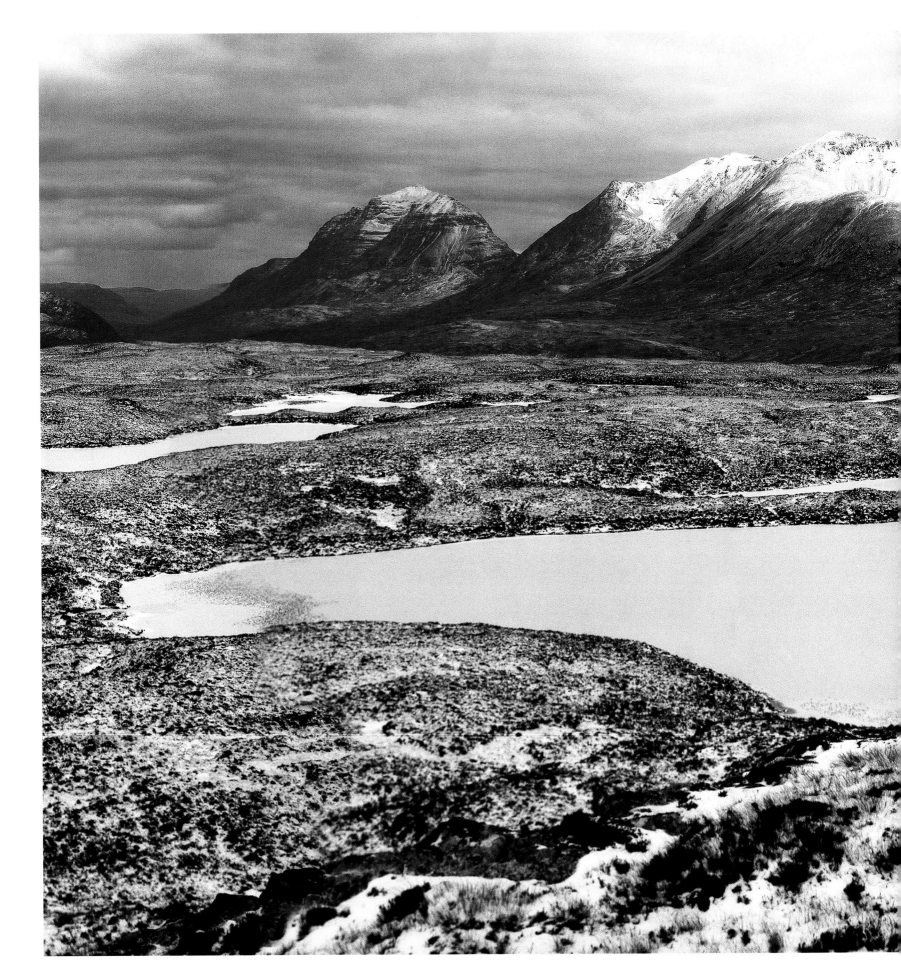

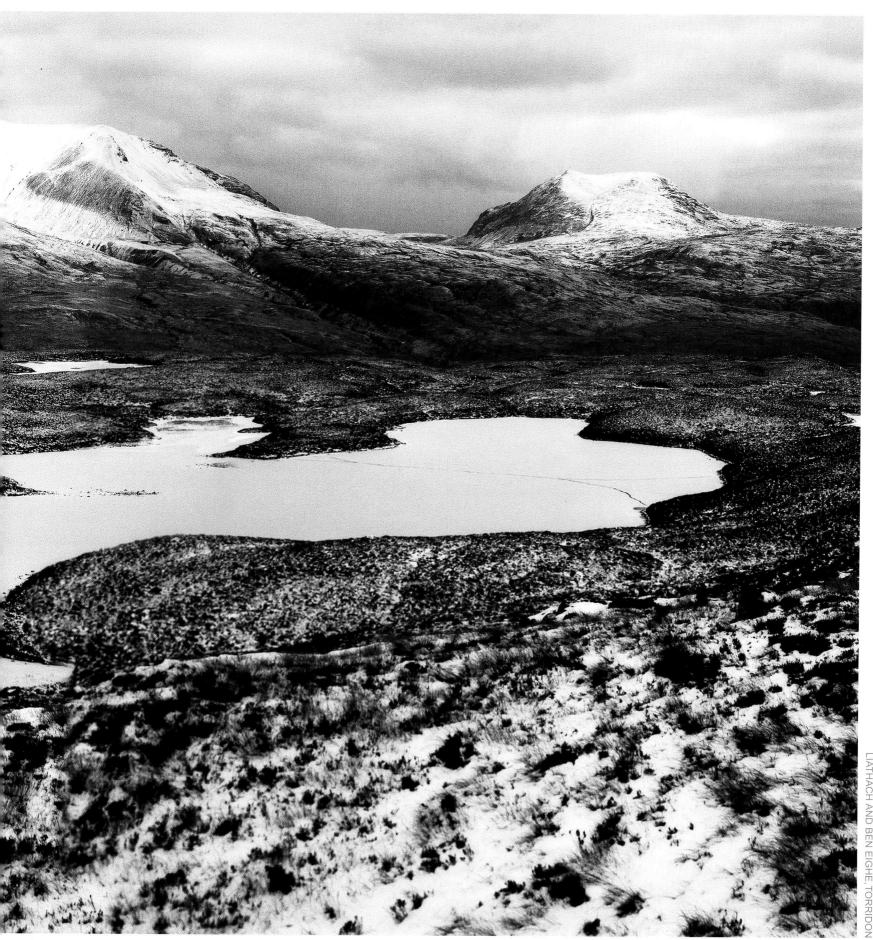

LIATHACH AND BEN EIGHE, TORRIDON

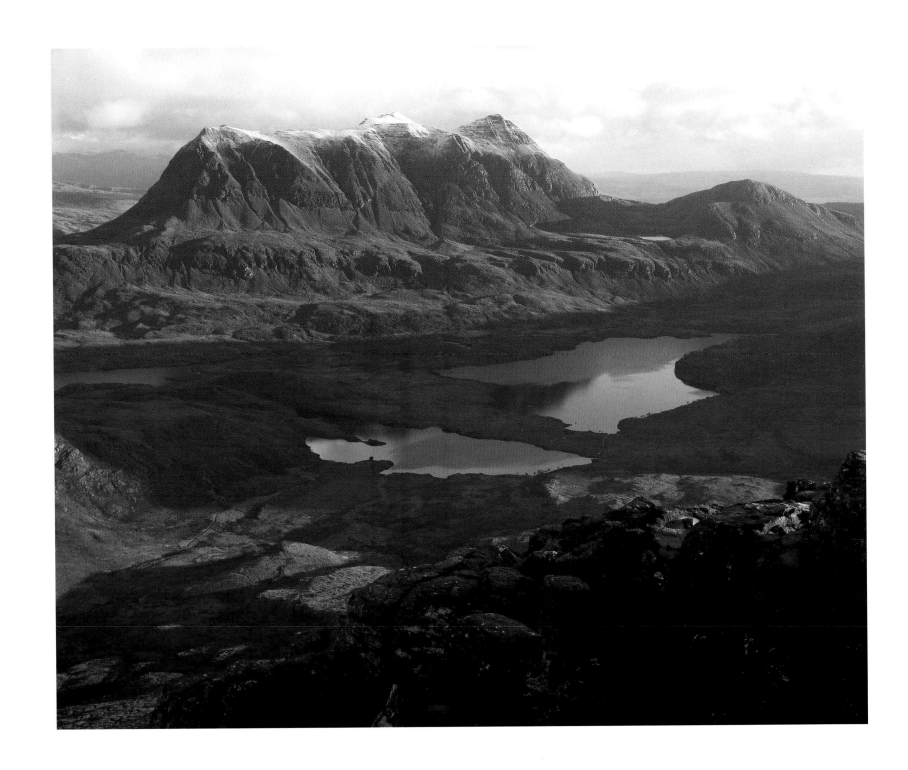

CUL MOR, INVERPOLLY

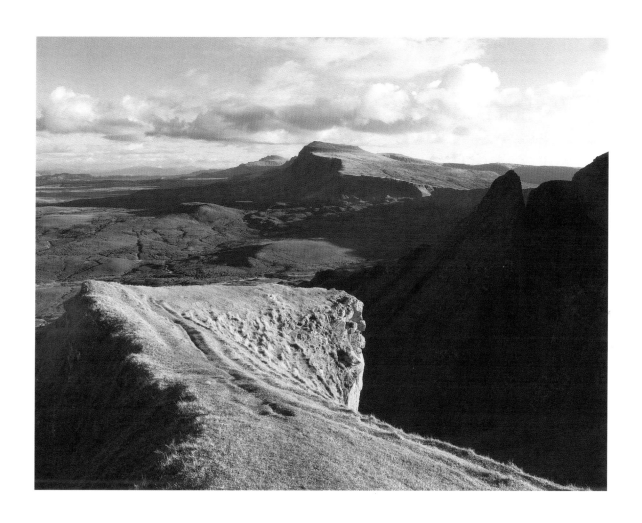

BEN EDRA FROM DUN DUBH, ISLE OF SKYE

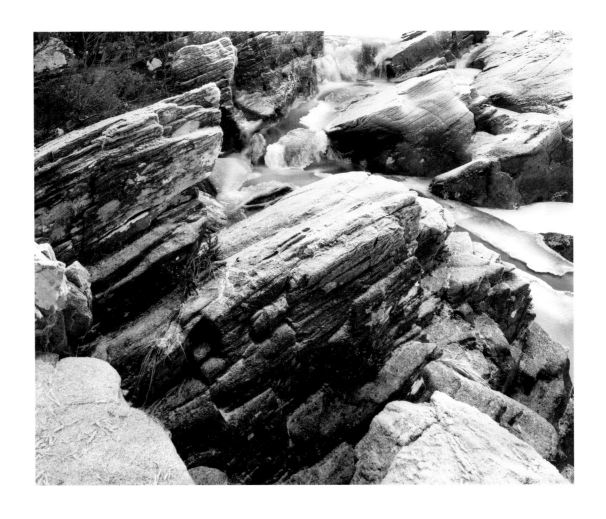

ICE AND ROCKS, A' GHAIRBHE, TORRIDON

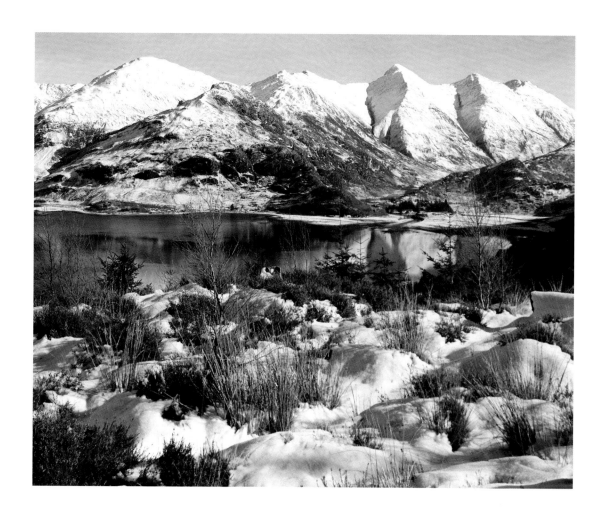

THE FIVE SISTERS OF KINTAIL, GLEN SHIEL

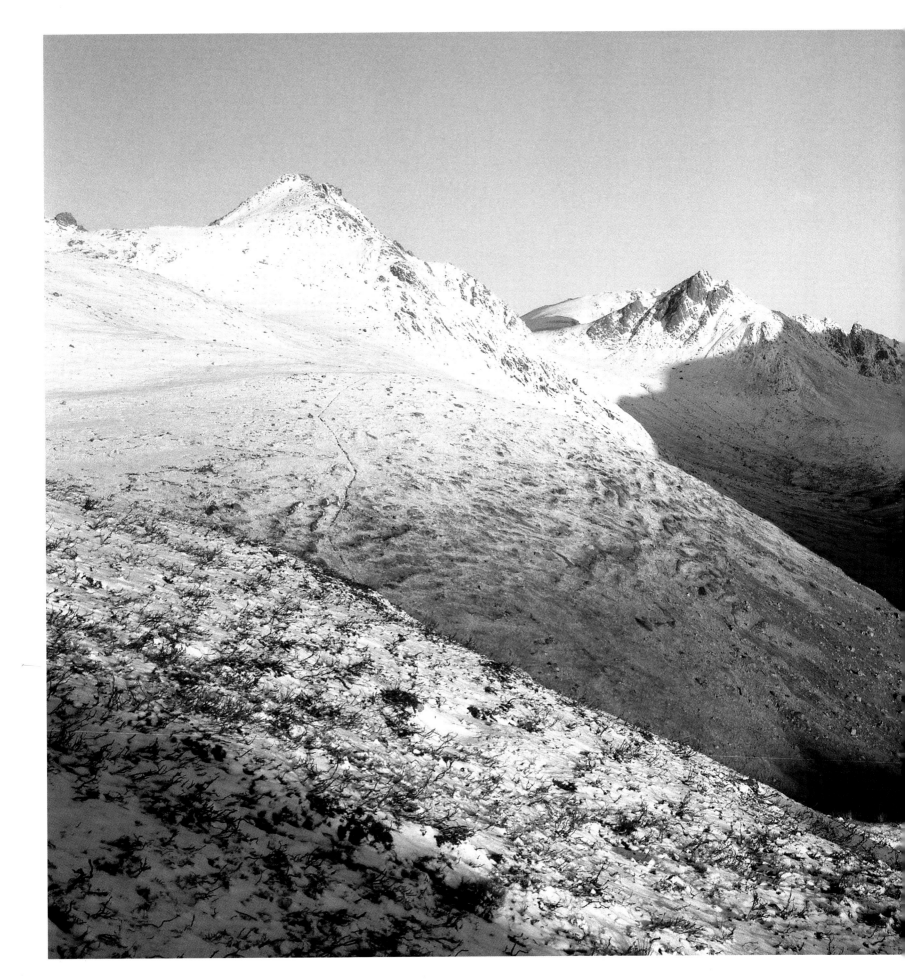

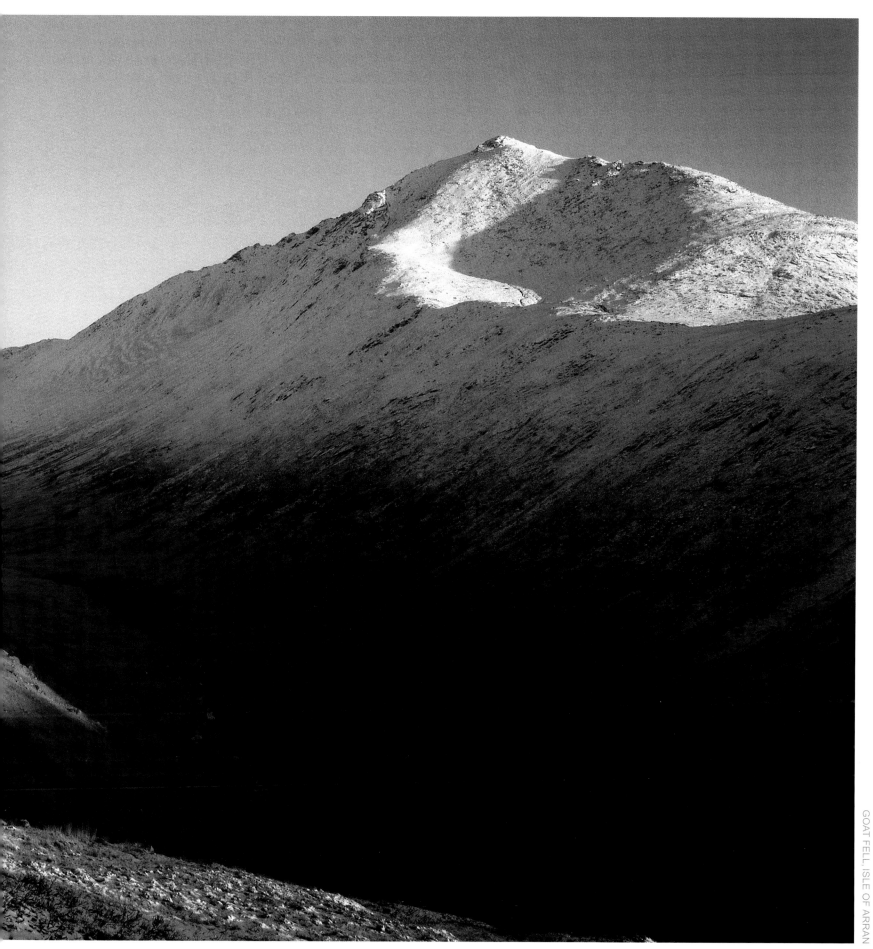

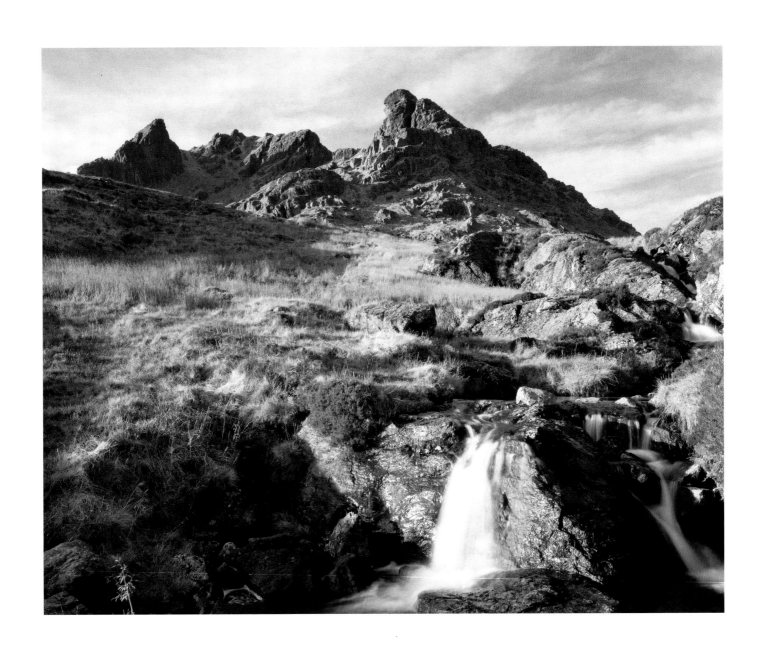

THE COBBLER FROM ALLT A' BHALACHAIN

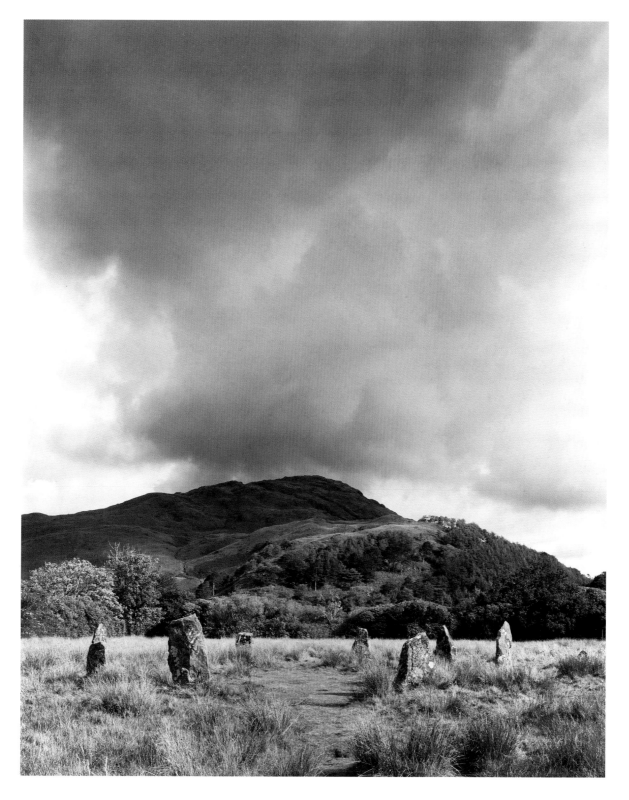

LOCH BUIE STONES, ISLE OF MULL

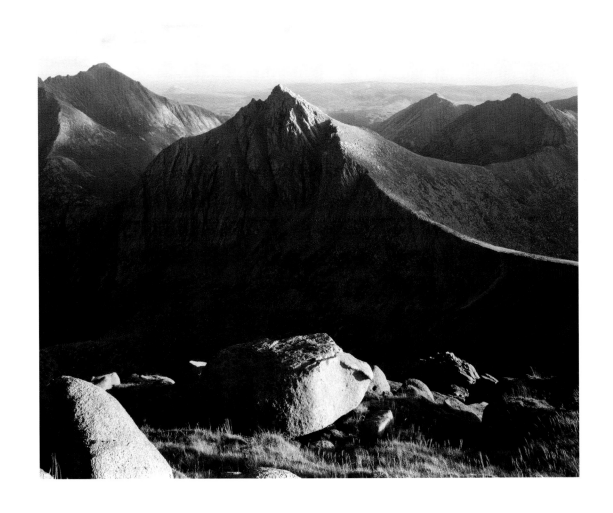

CHIR MHOR, ISLE OF ARRAN

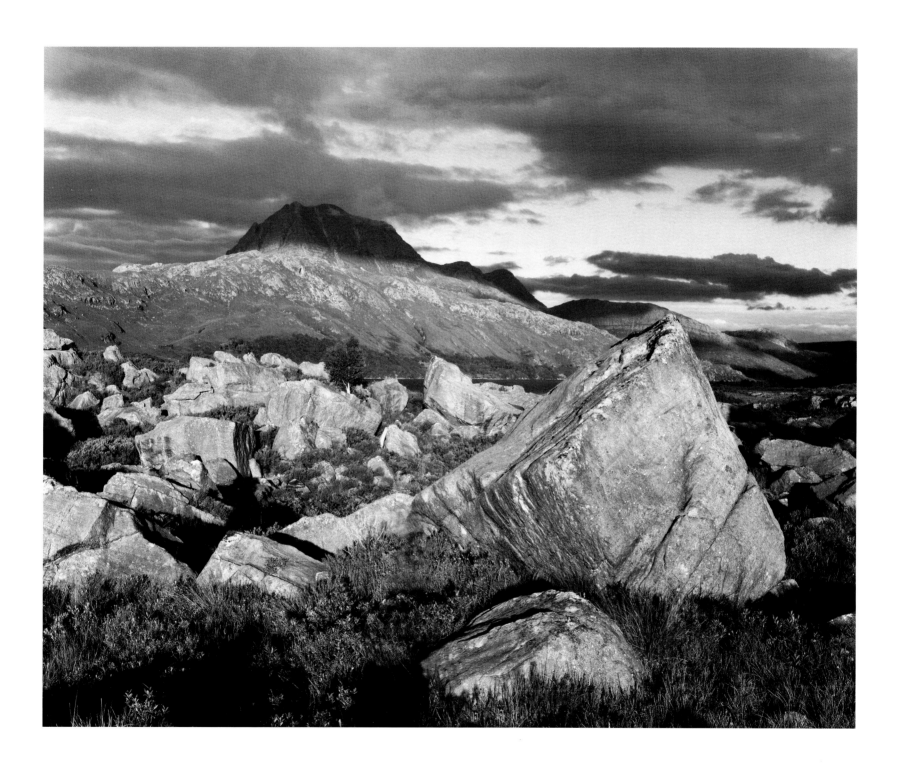

SLIOCH AND BOULDER FIELD, WESTER ROSS

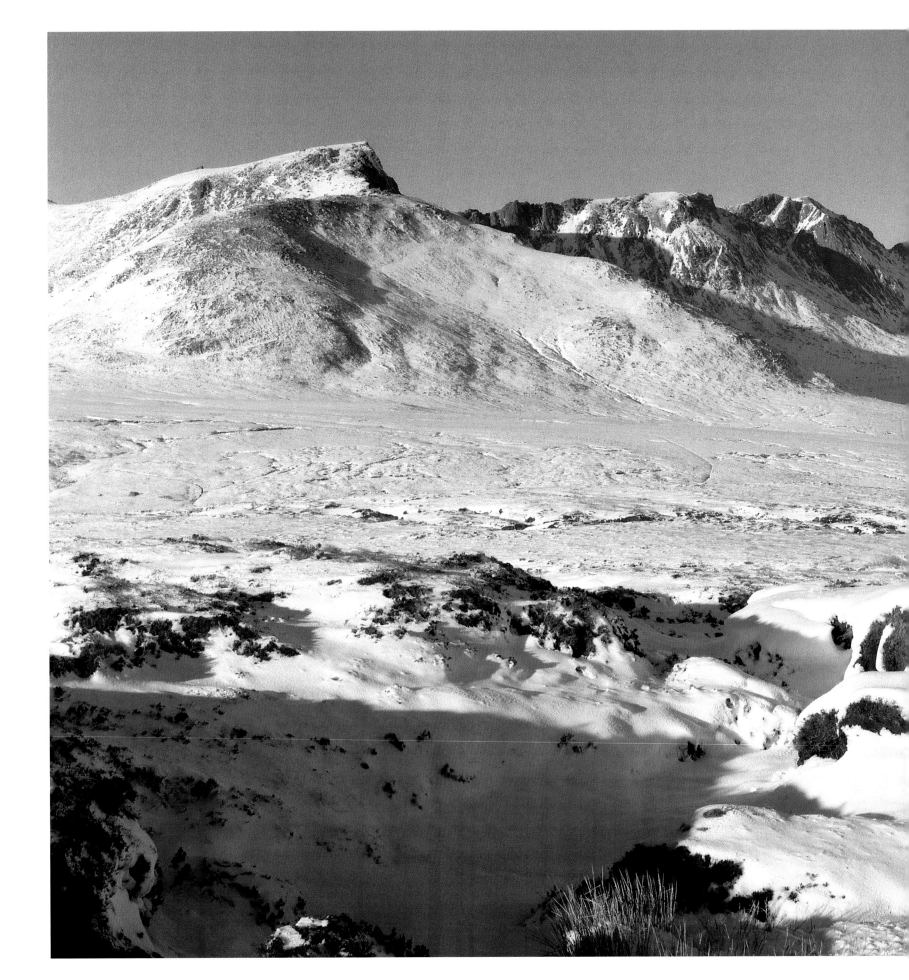

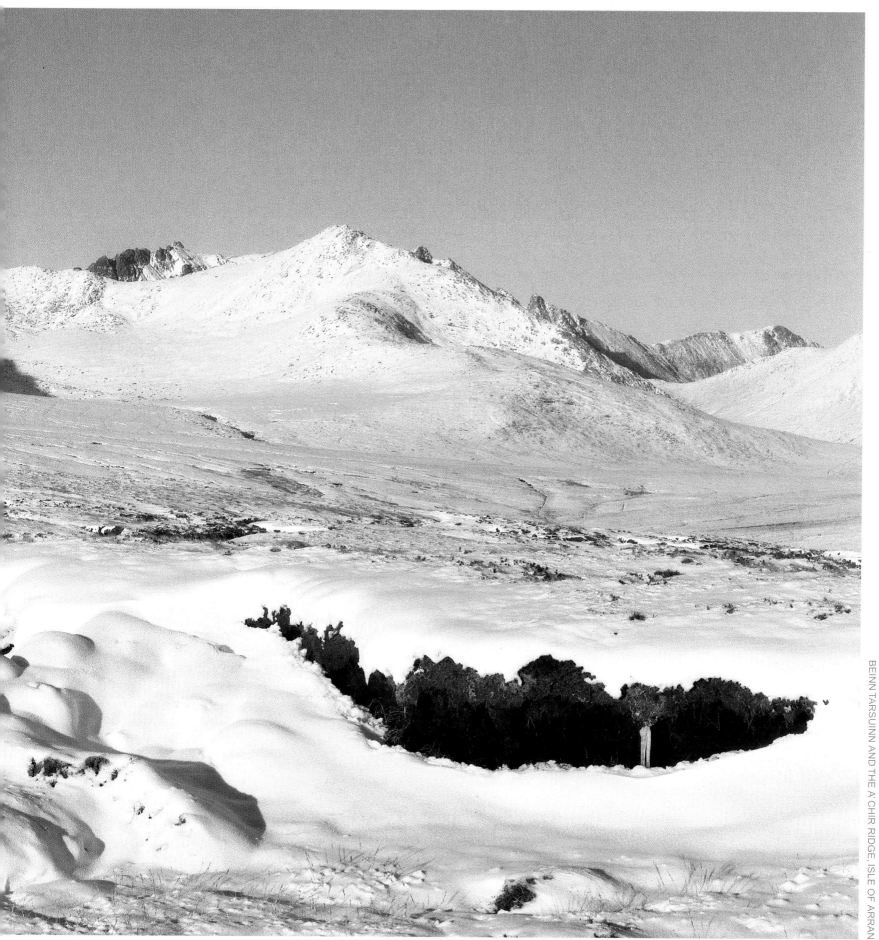

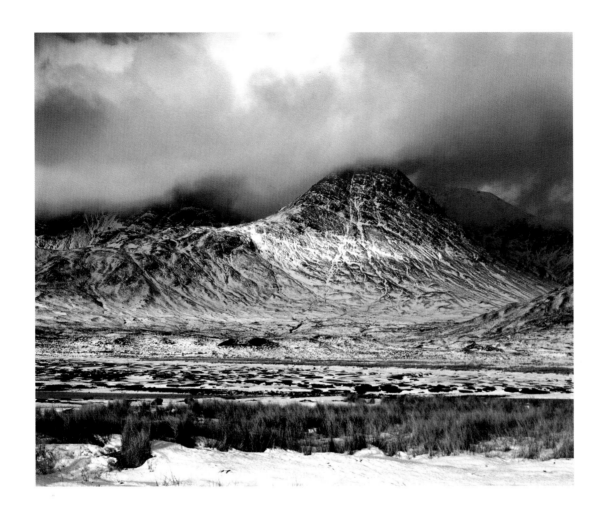

BLAVEN FROM LOCH SLAPIN, ISLE OF SKYE

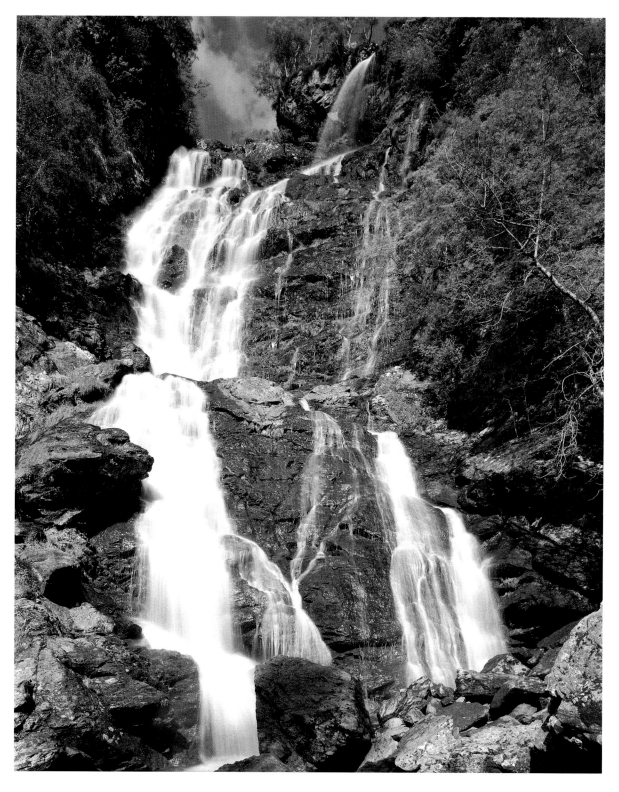

BEN GLAS FALLS, INVERARNAN

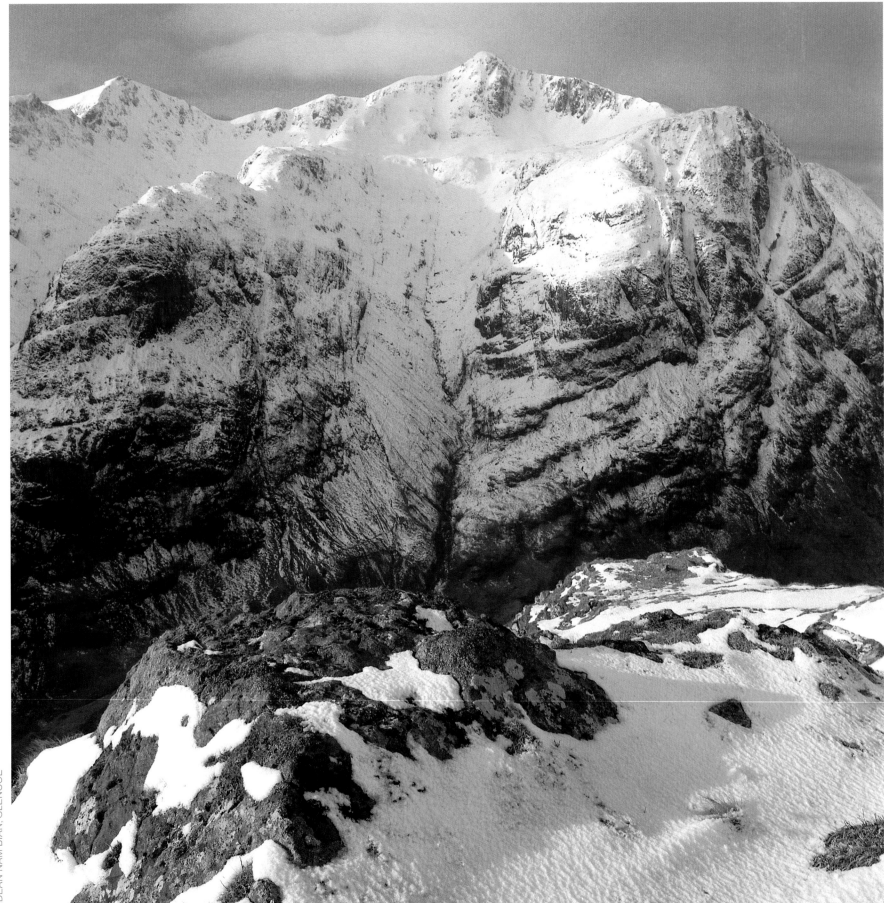

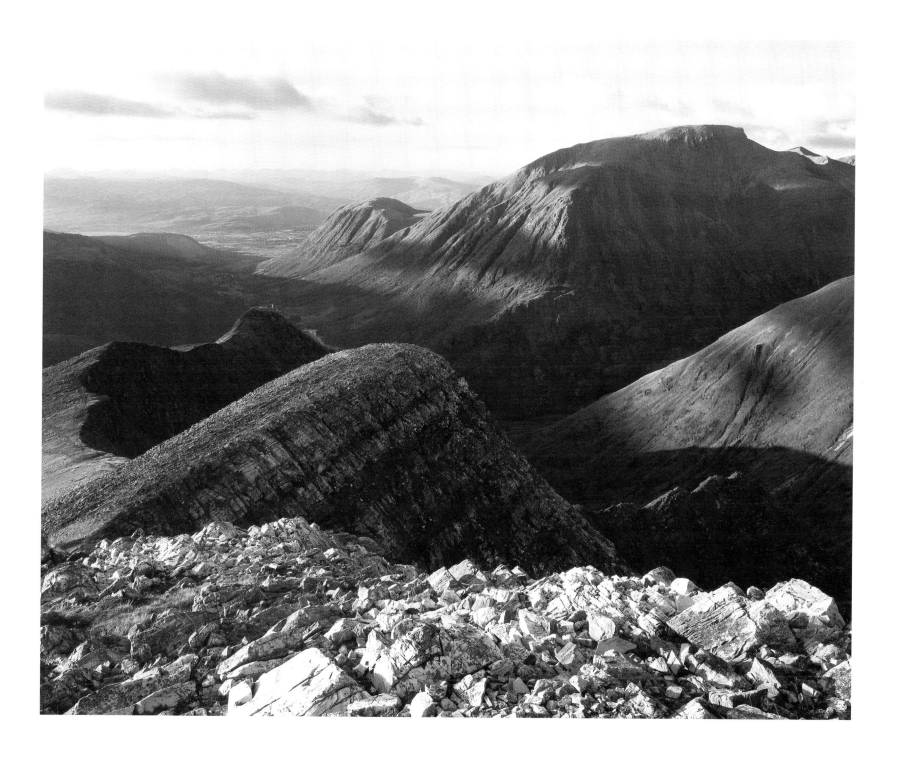

BEN NEVIS

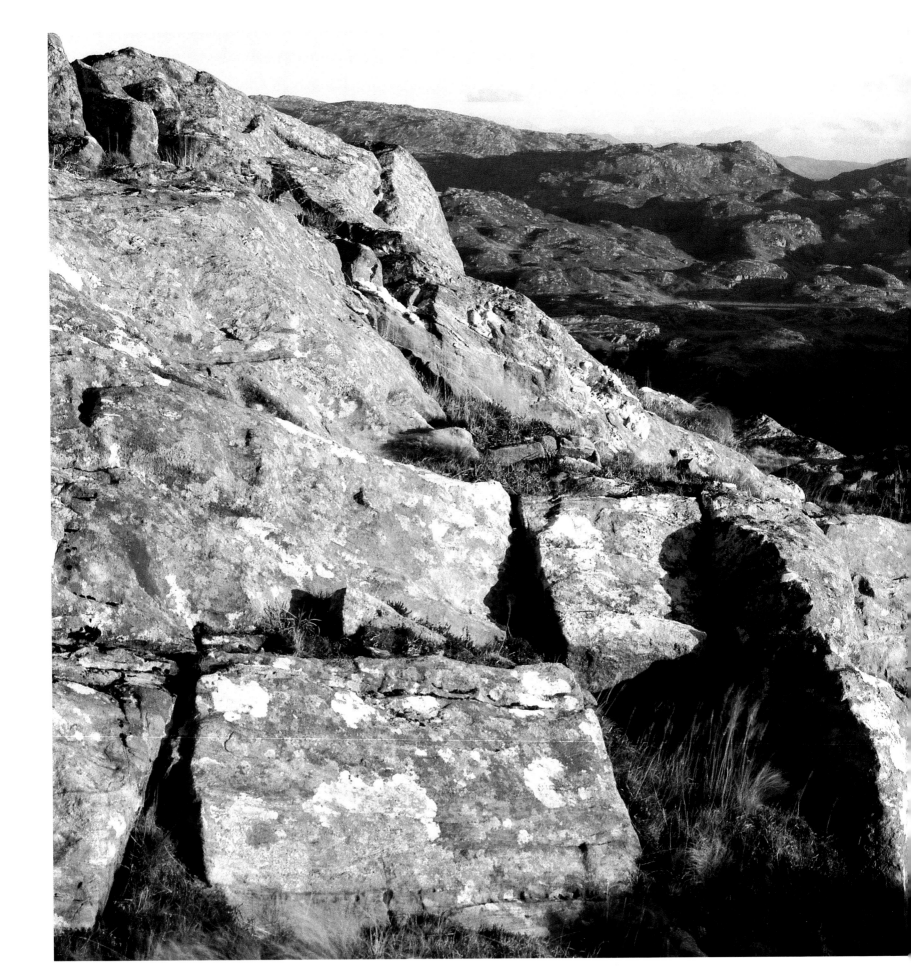

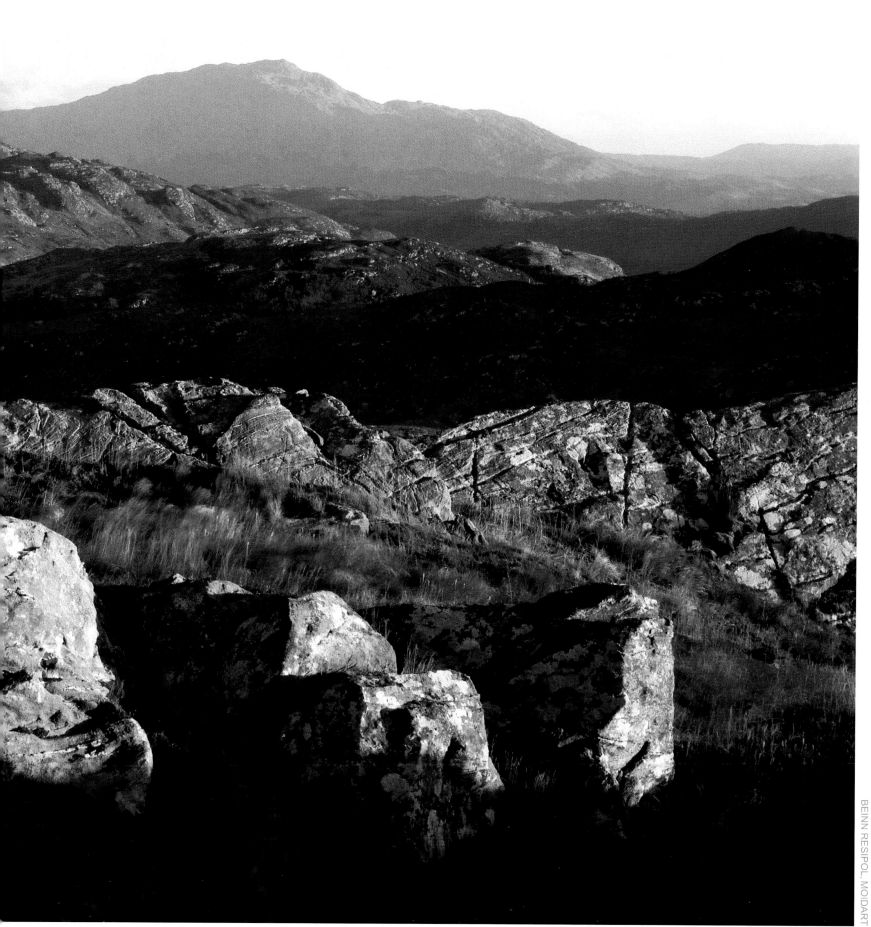

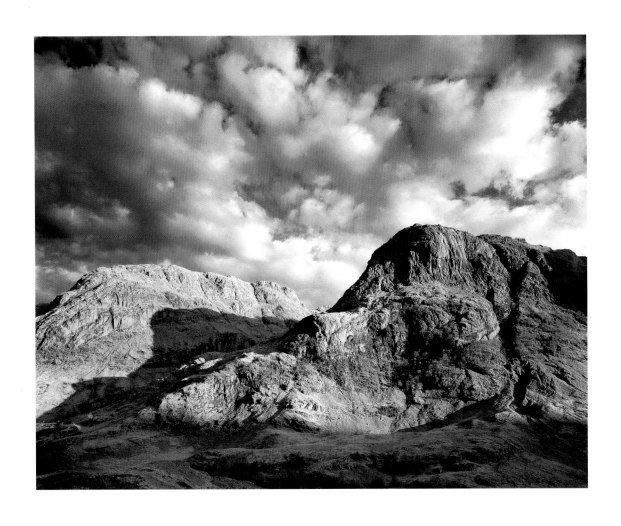

GEARR AONACH AND BEINN FHADA, GLENCOE

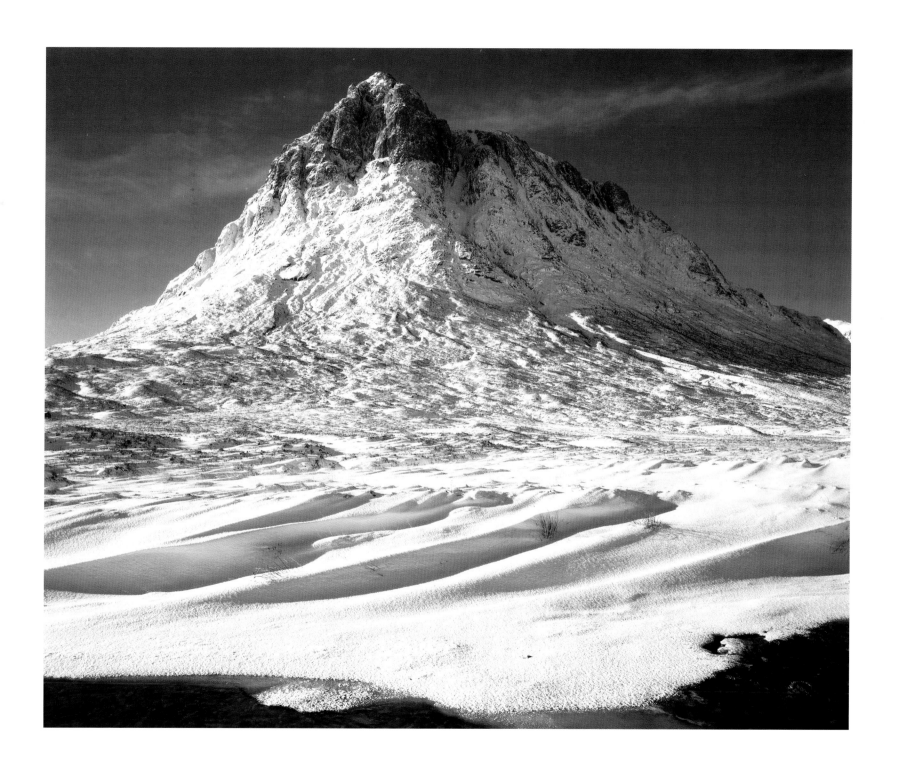

STOB DEARG, BUACHAILLE ETIVE MOR, GLENCOE

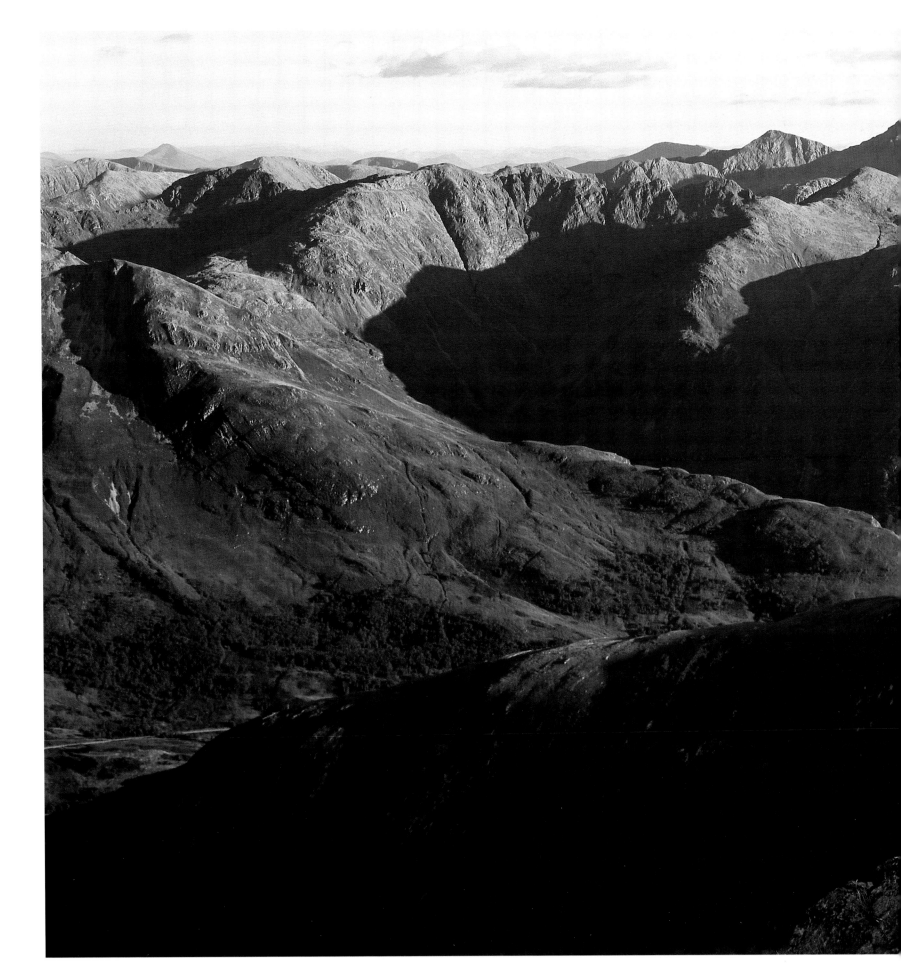

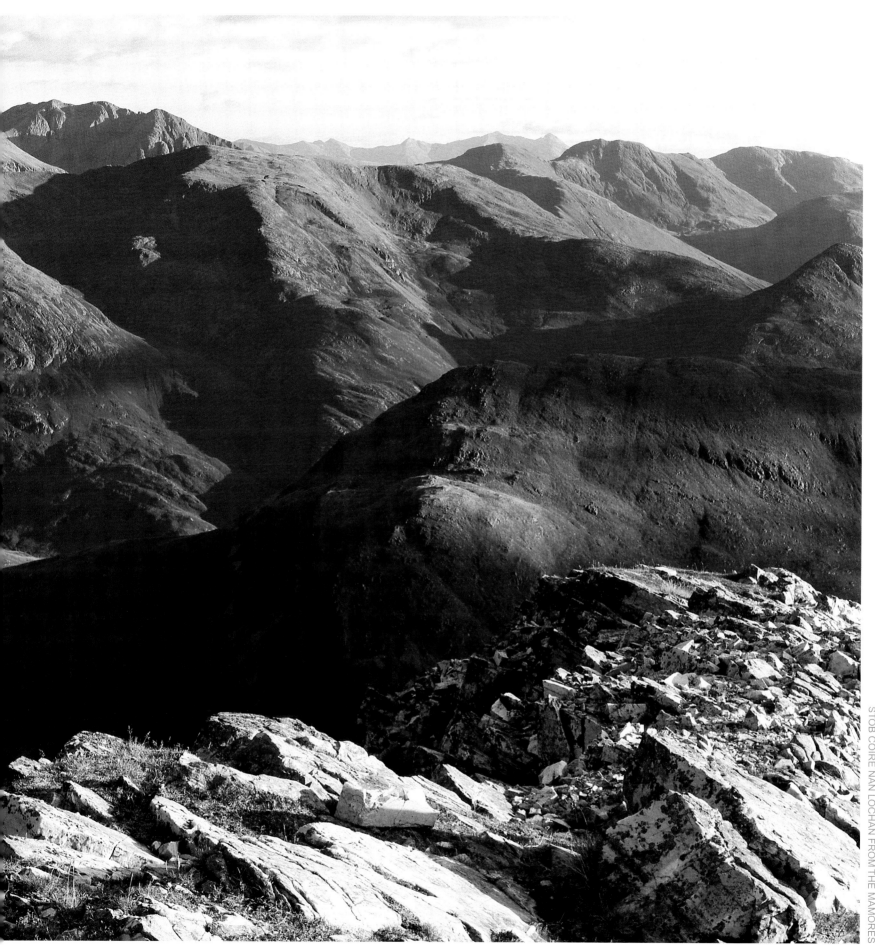

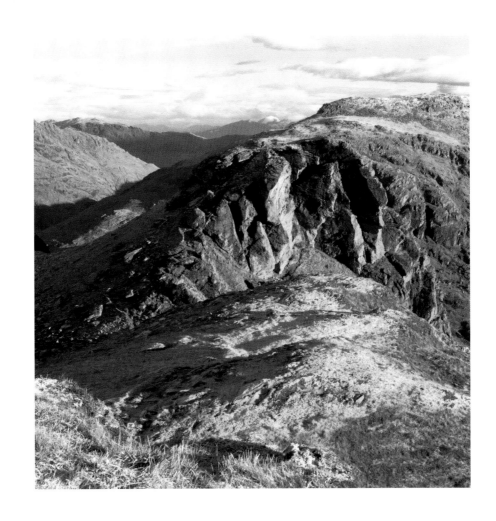

THE ARROCHAR ALPS

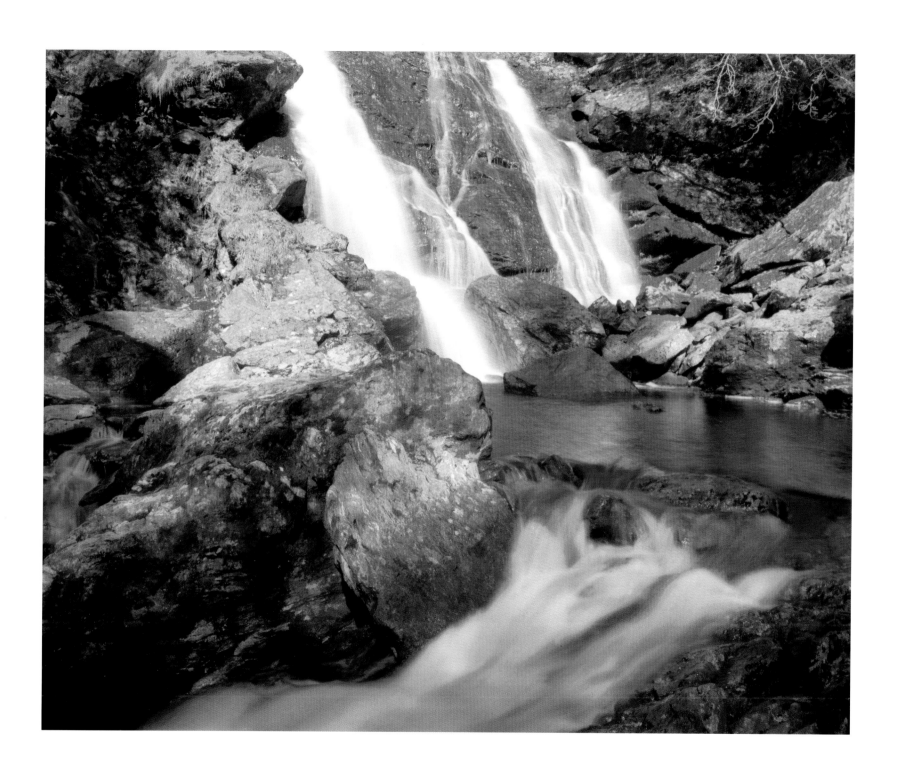

BEN GLAS FALLS DETAIL, INVERARNAN

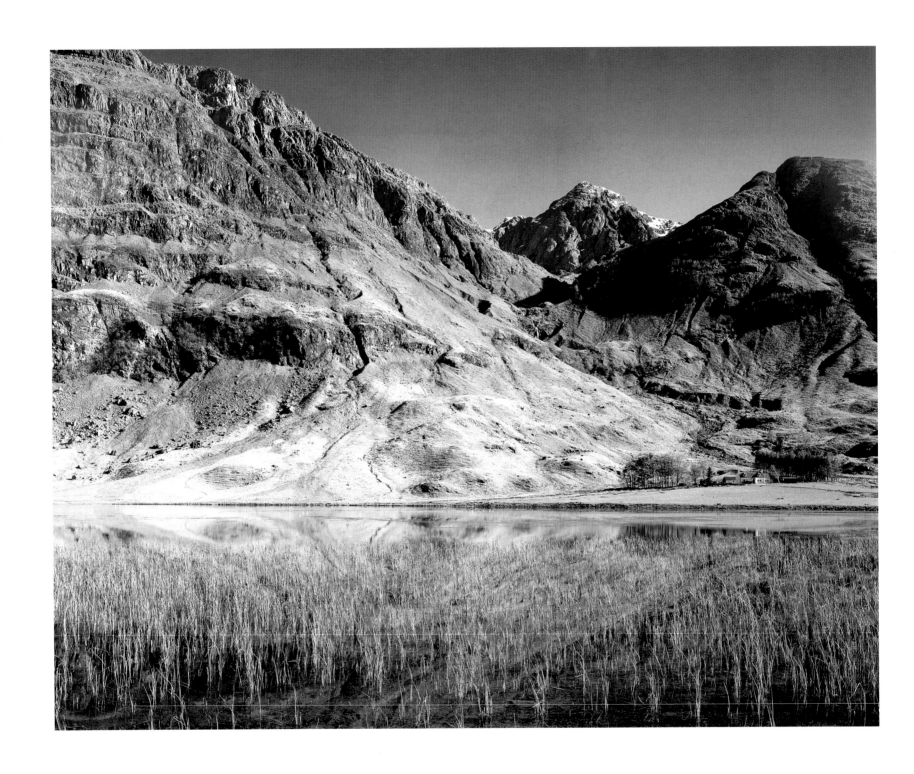

AONACH DUBH AND LOCH ACHTRIOCHTAN, GLENCOE

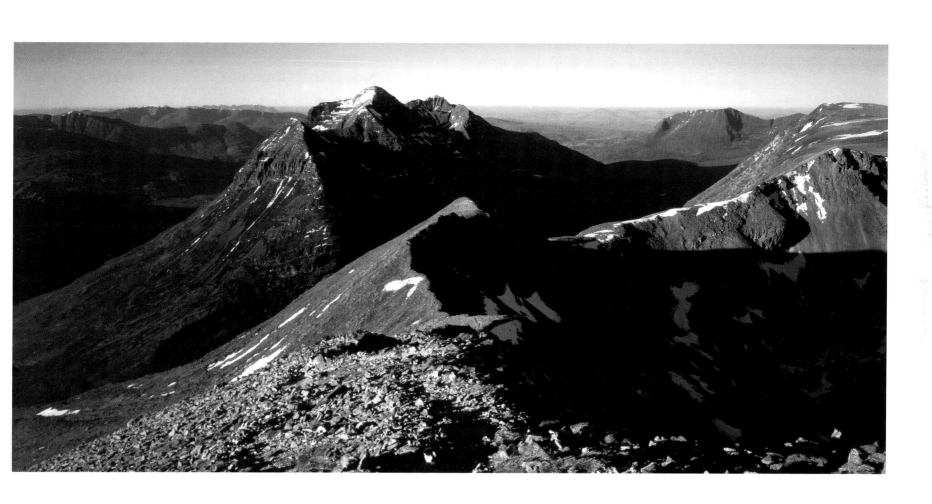

LIATHACH AT DAWN FROM BEN EIGHE

COASTLINE

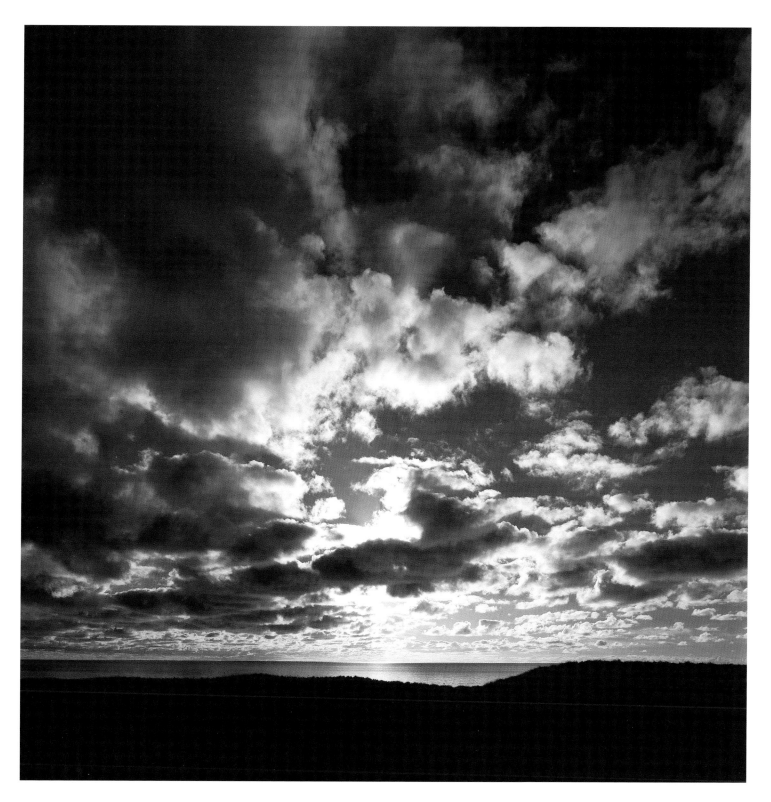

SUNSET, ISLE OF HARRIS

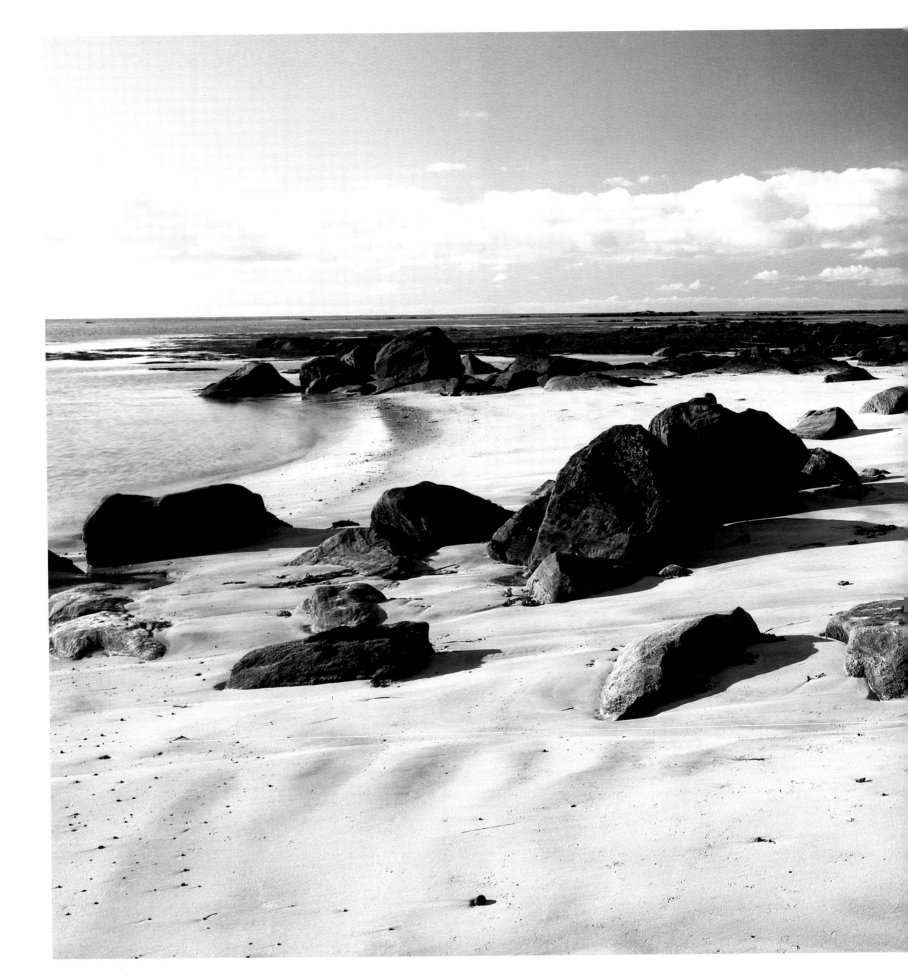

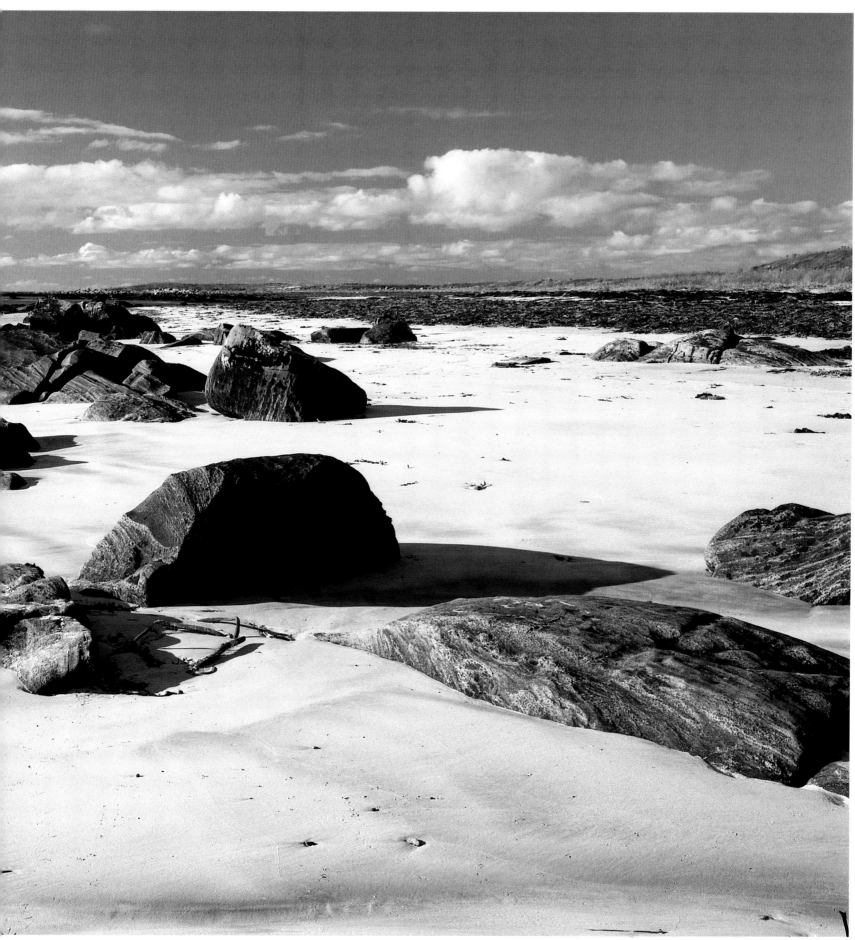

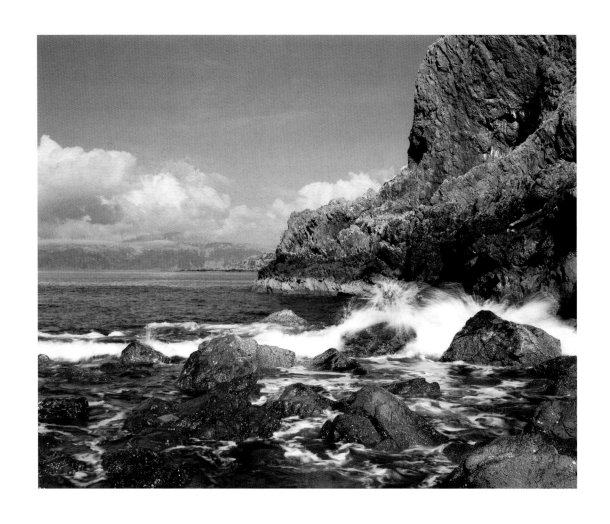

FIRTH OF LORN, ISLE OF SEIL

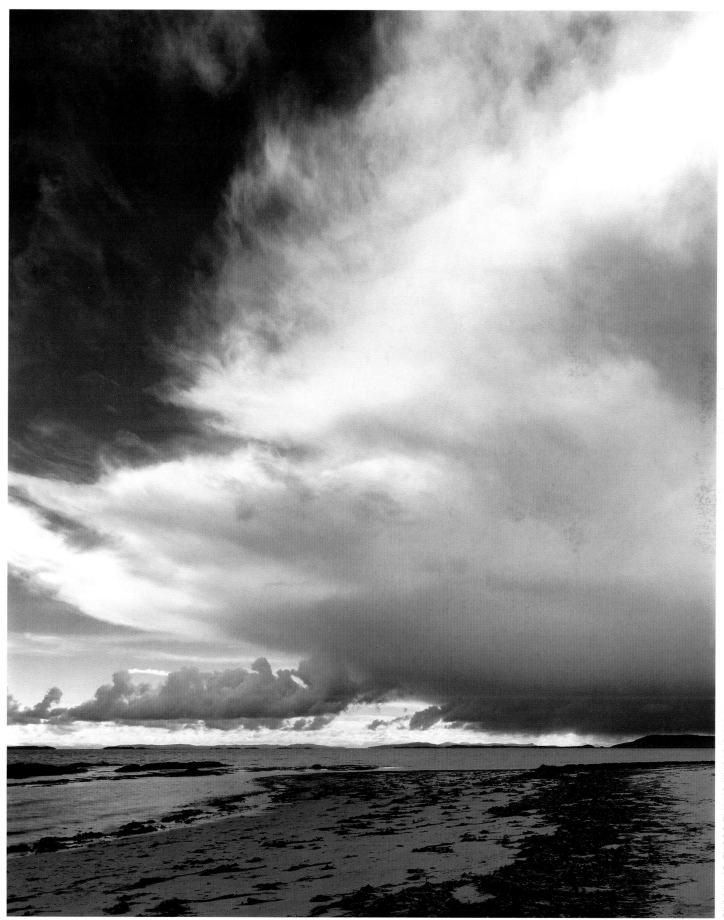

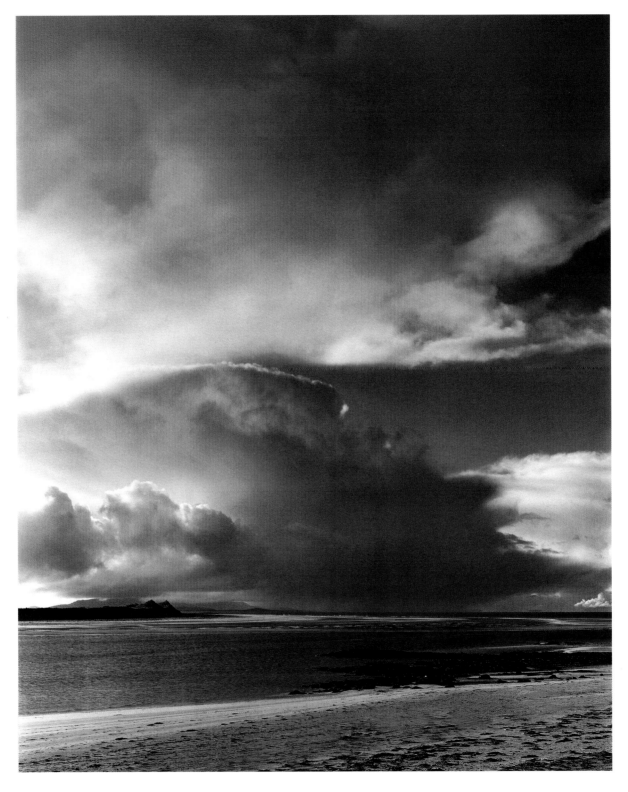

KIRKIBOST AND STORM CLOUDS, ISLE OF NORTH UIST

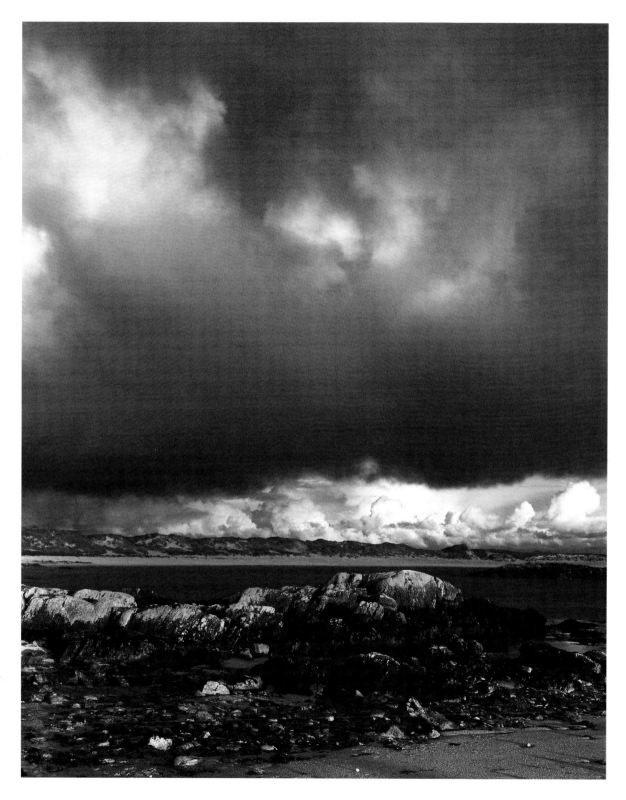

FORESHORE AND STORM, ISLE OF SOUTH UIST

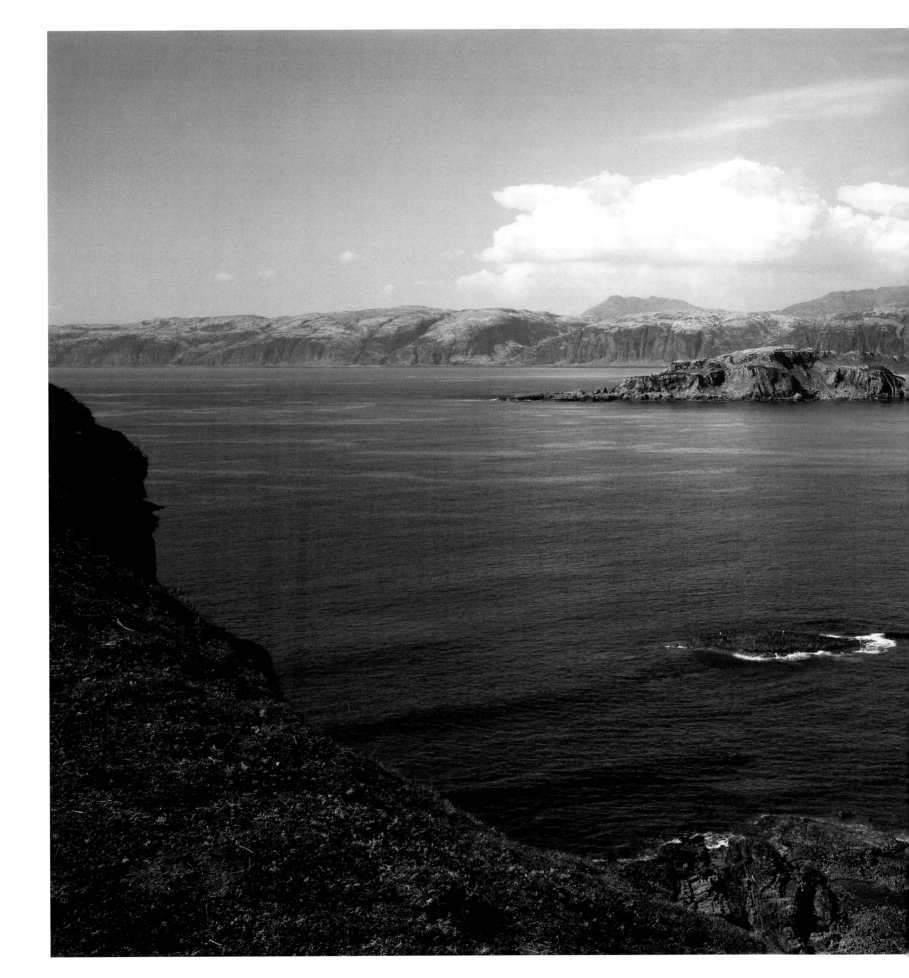

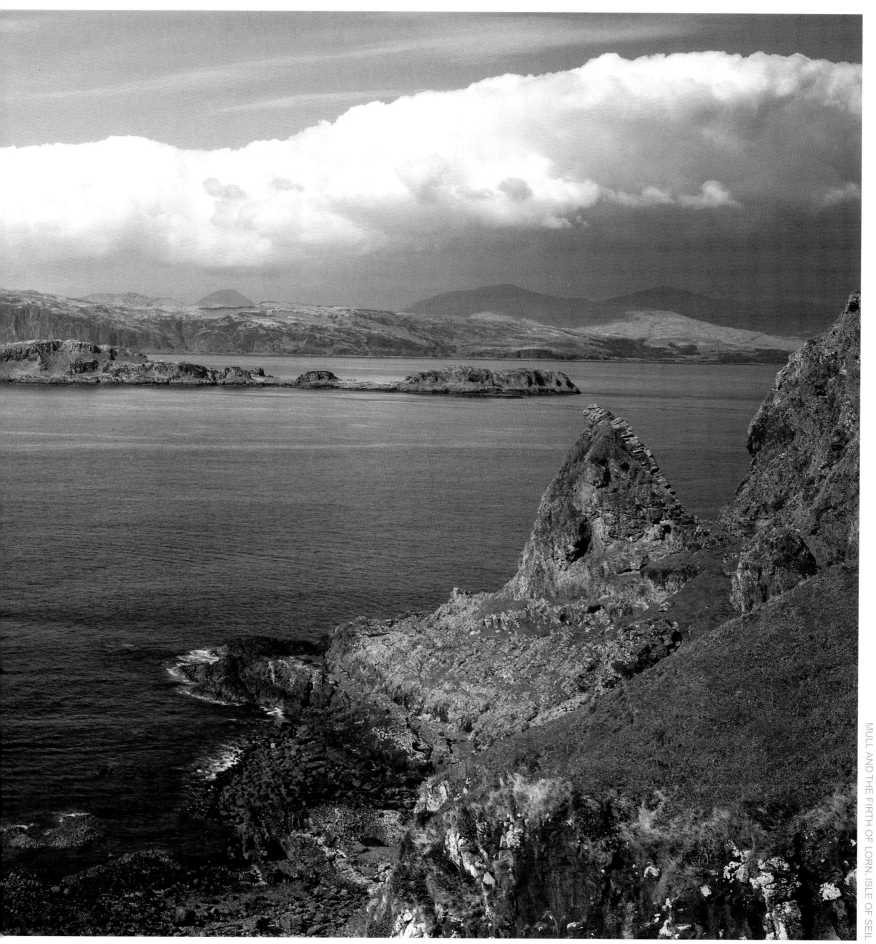

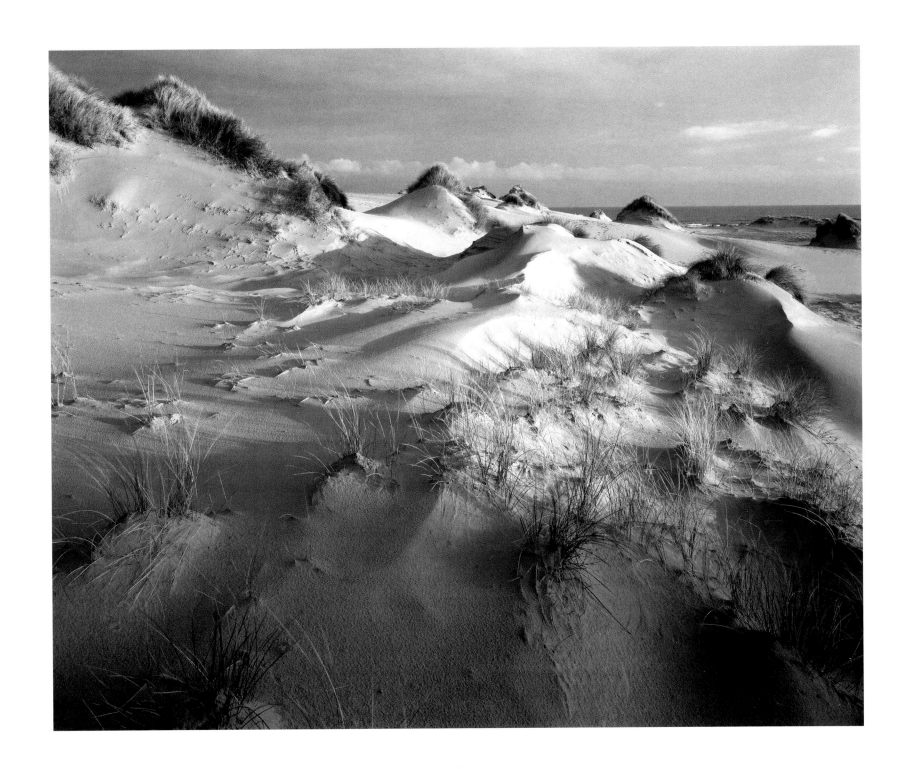

SAND DUNES, FORVIE

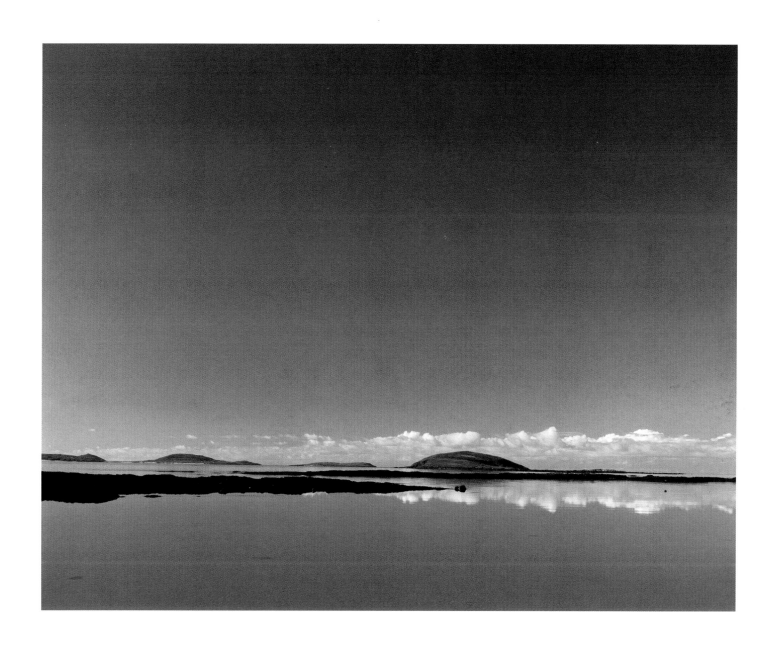

FUDAY ISLAND, ISLE OF ERISKAY

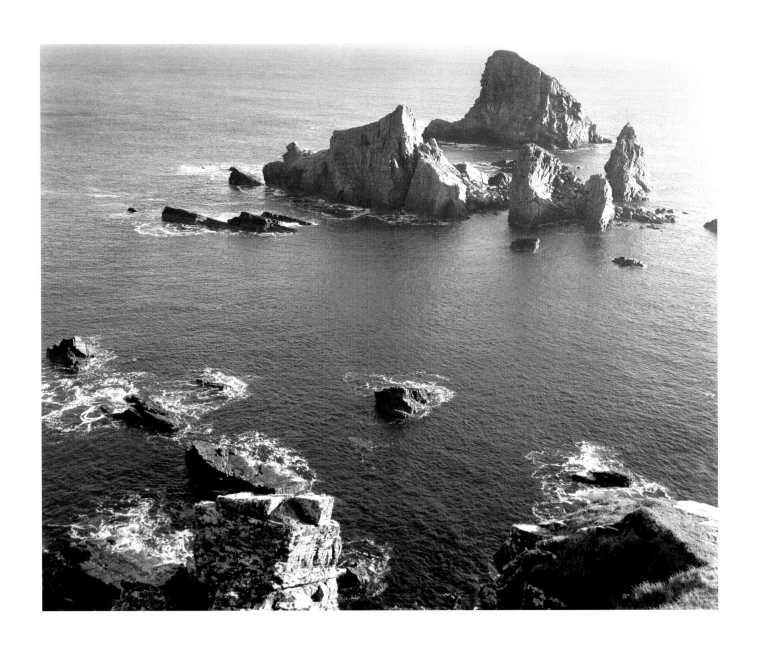

. CLACH NA FARAID, CAPE WRATH

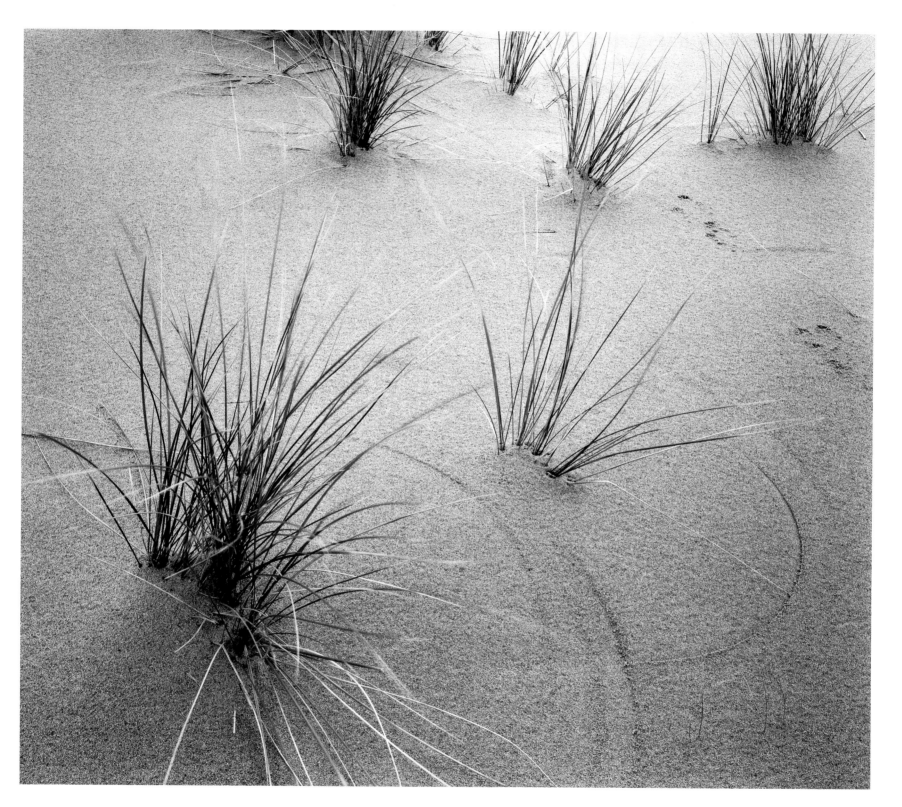

SAND AND GRASSES, FORVIE

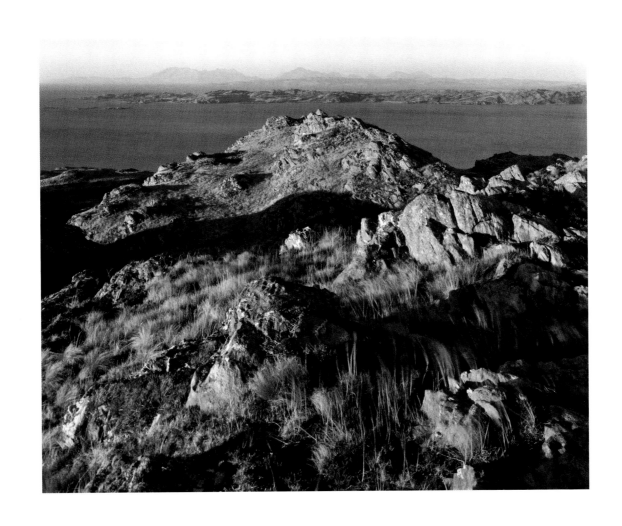

CRUACH NA BAIRNESS, MOIDART

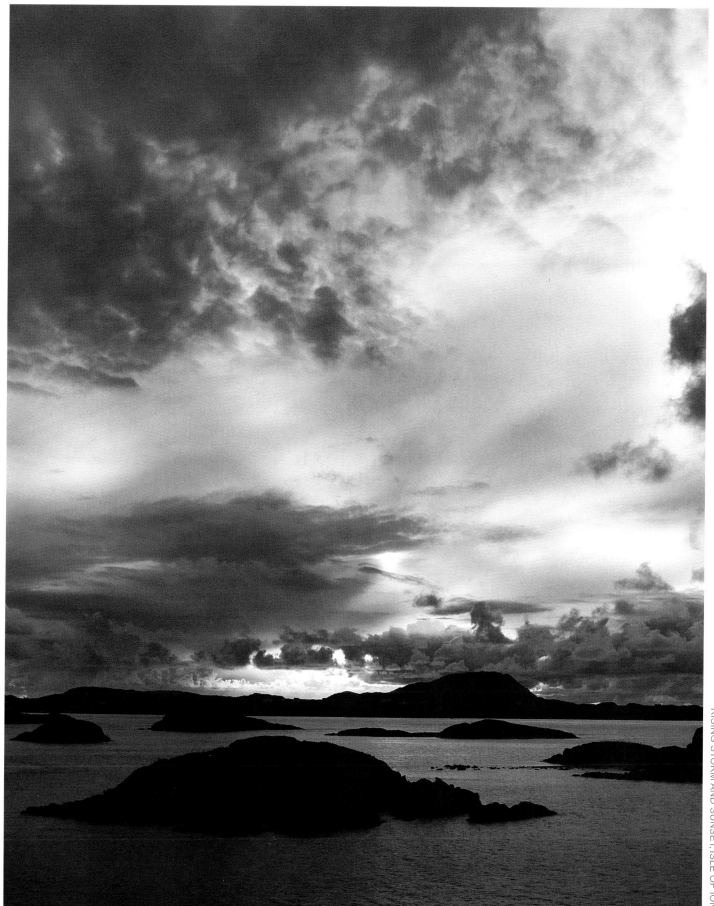

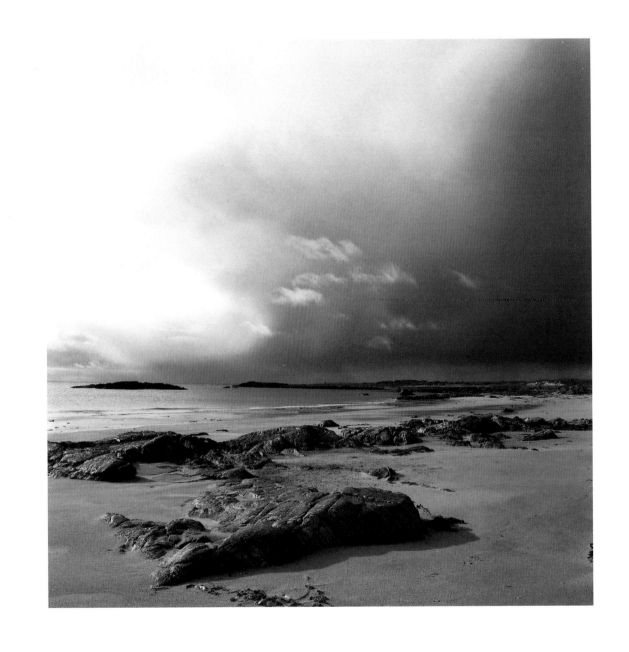

BALRANALD NATURE RESERVE, ISLE OF NORTH UIST

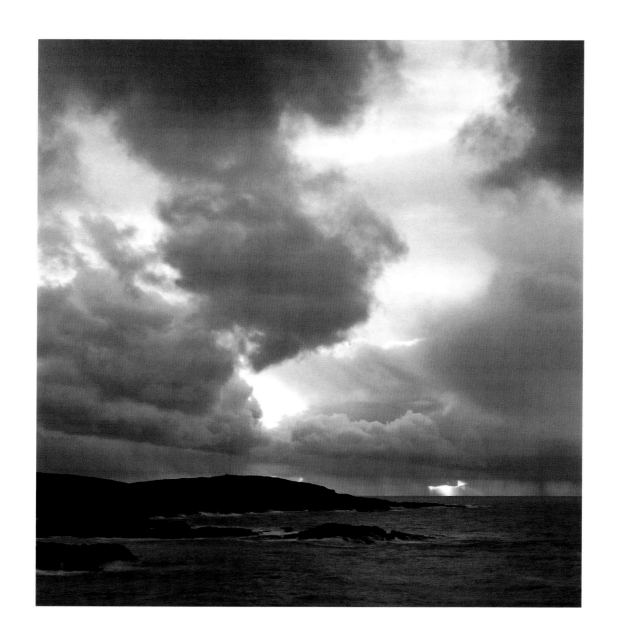

TRAIGH STIR, ISLE OF NORTH UIST

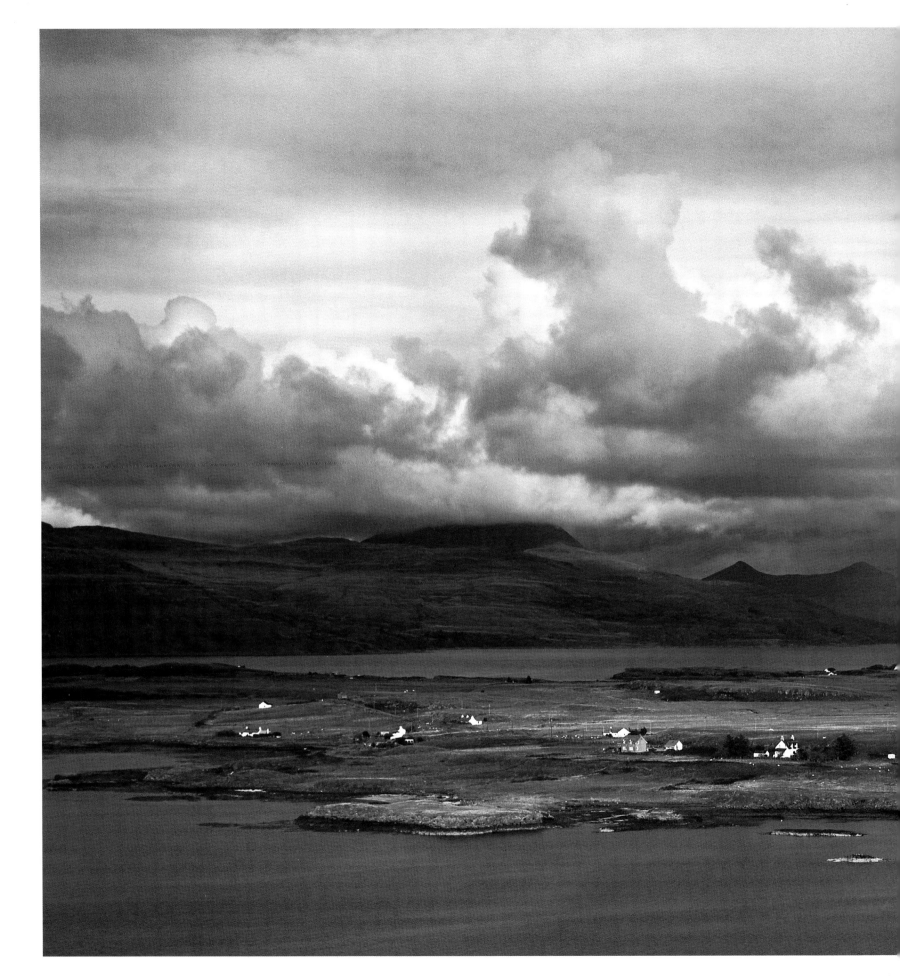

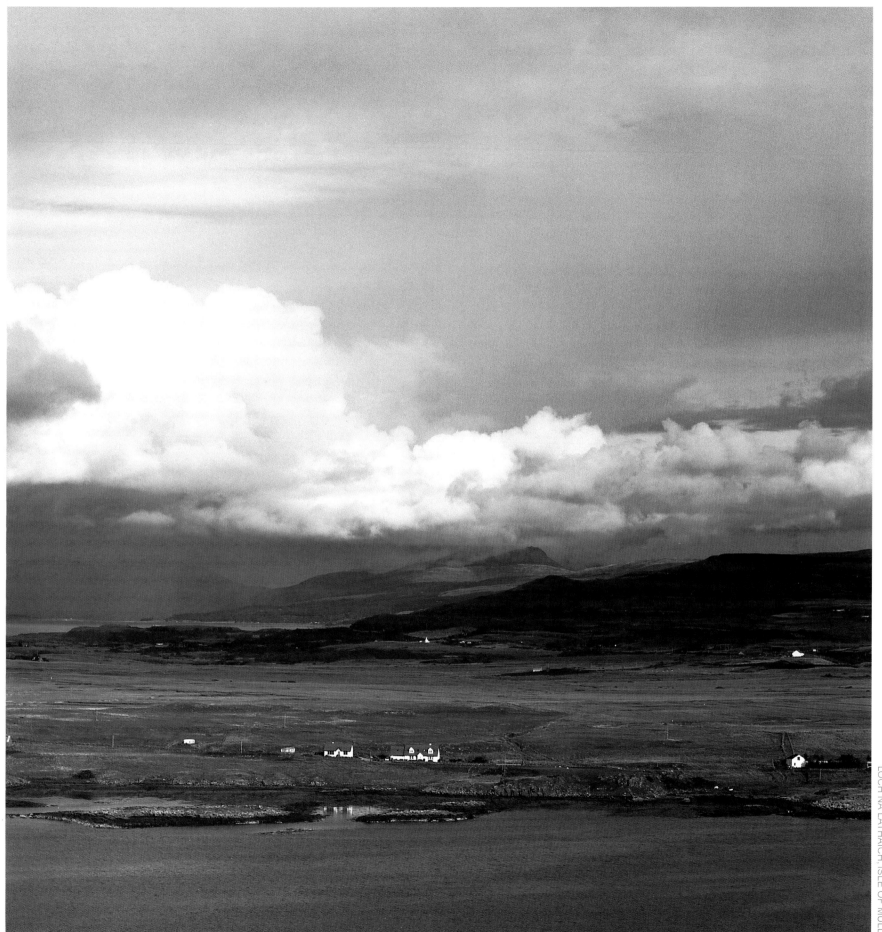

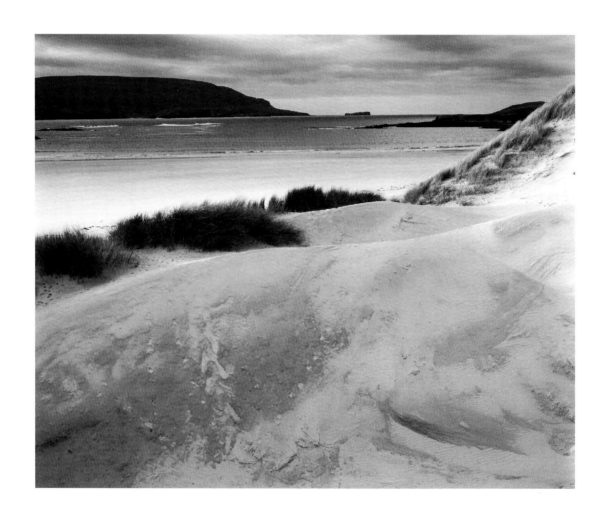

SAND DUNES, FARAID HEAD

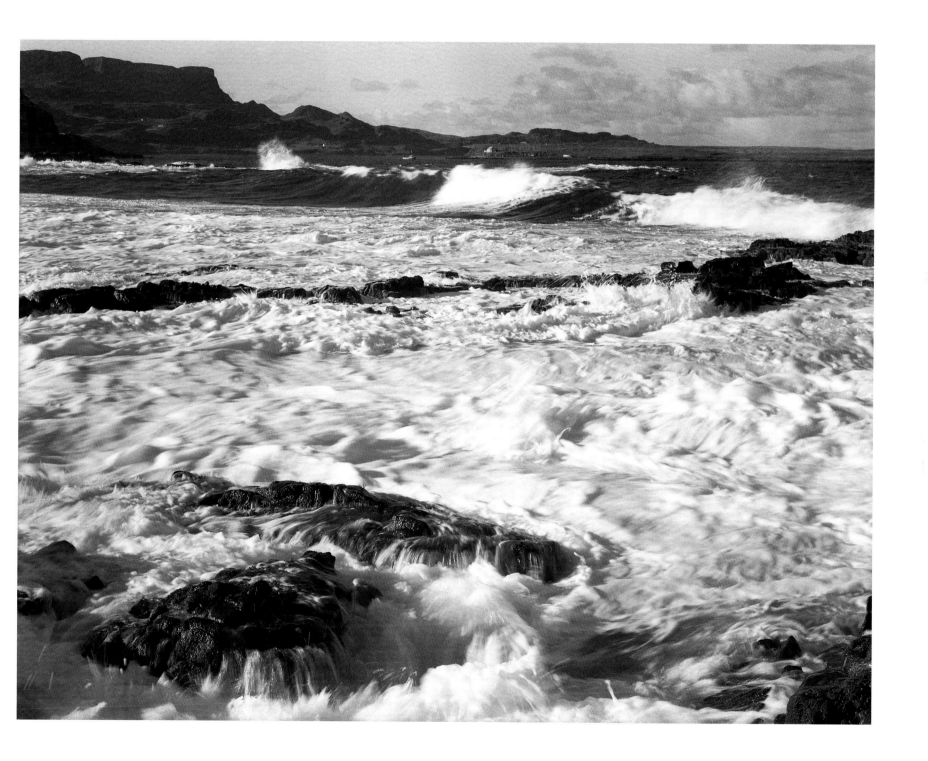

SURF, ISLE OF SKYE

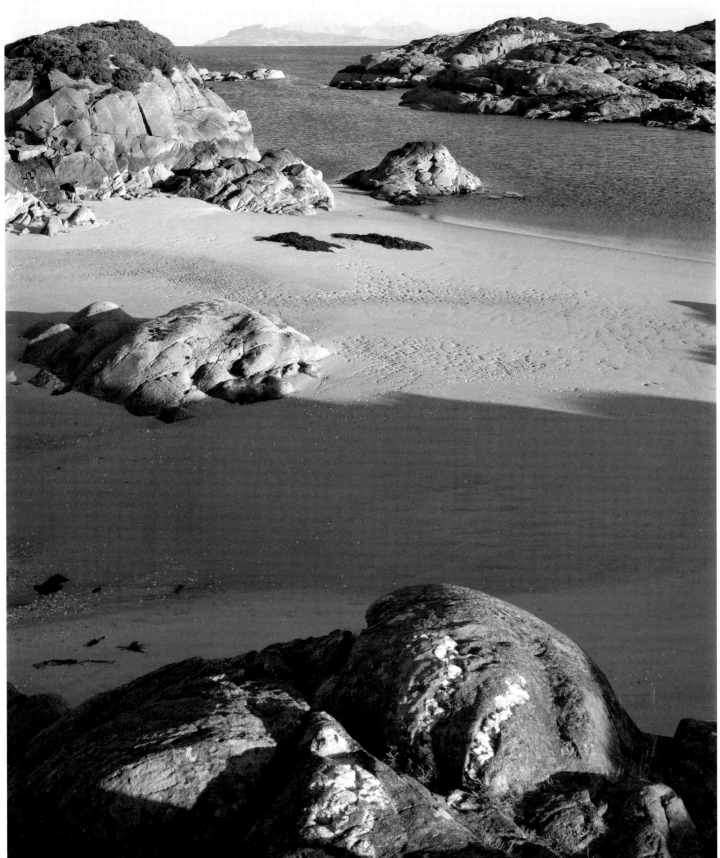

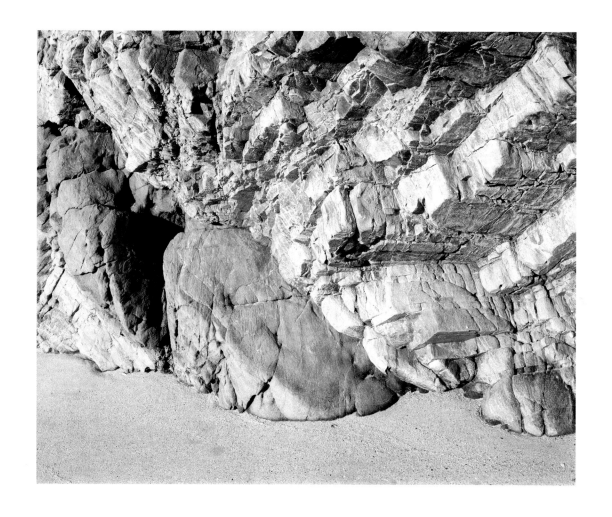

SAND AND ROCK DETAIL, FARAID HEAD, CAPE WRATH

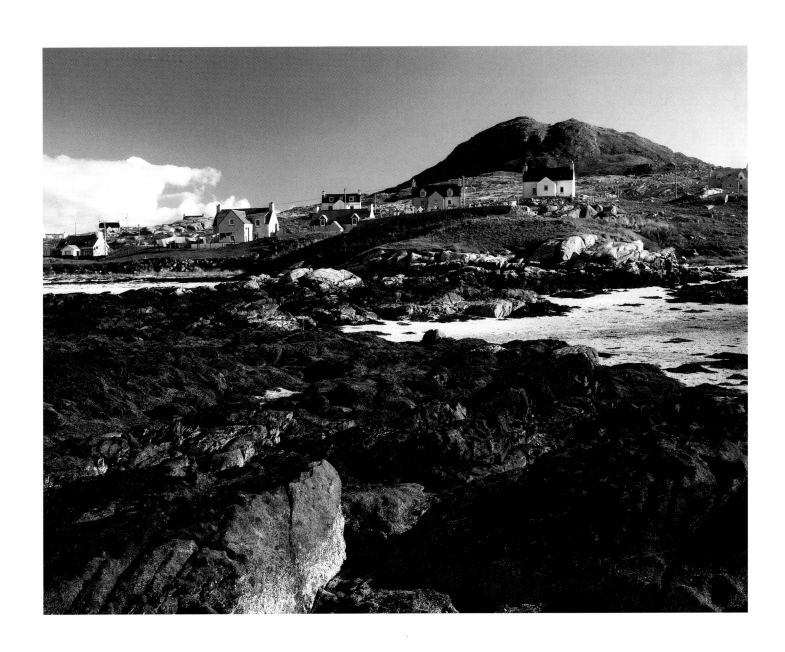

AM BAILE AND FORSHORE, ISLE OF ERISKAY

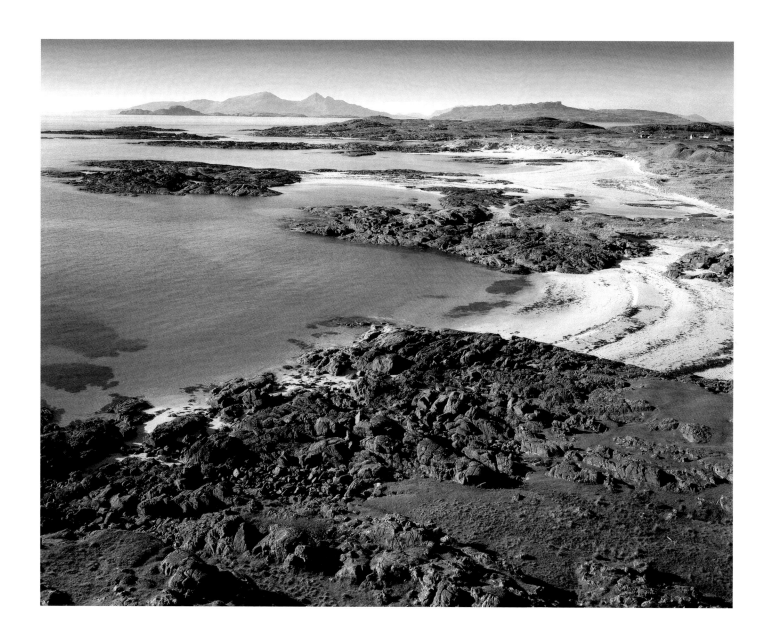

SANNA BAY, ARDNAMURCHAN

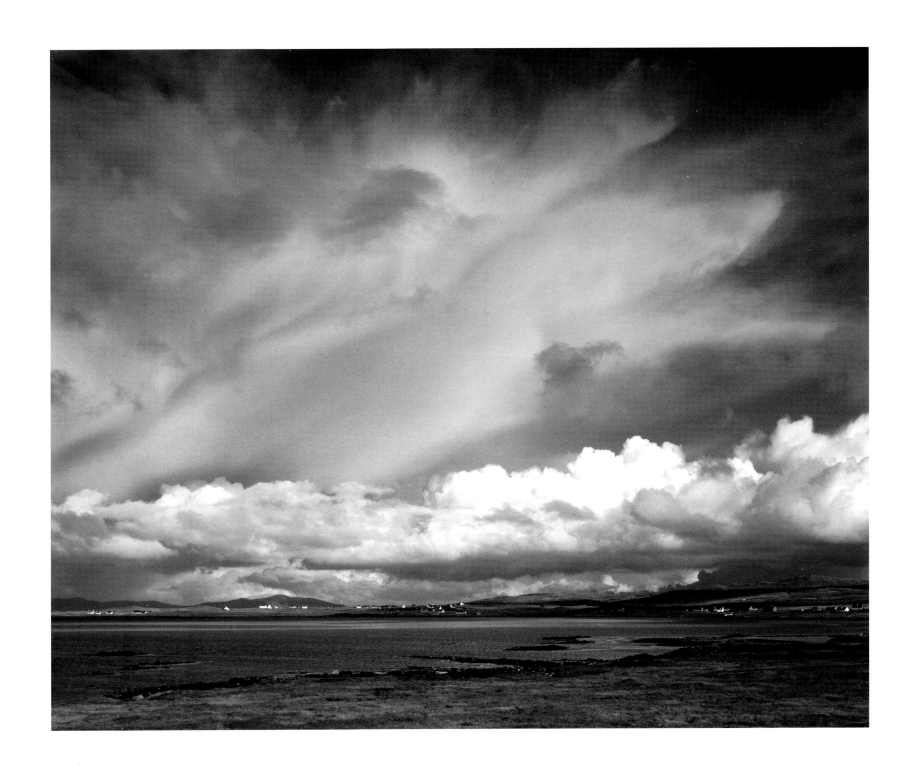

TRAIGH BHALAIGH AND CLOUDS, ISLE OF NORTH UIST

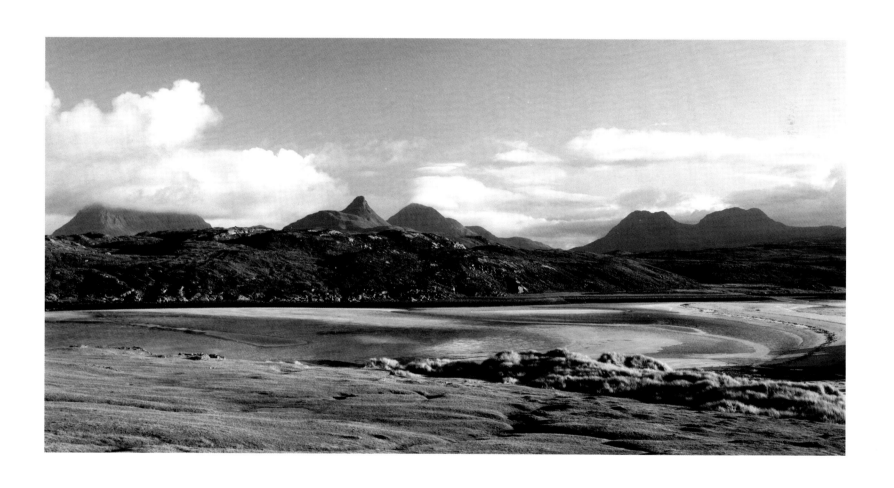

CUL MOR AND STAC POLLAIDH FROM ACHNAHAIRD BAY, INVERPOLLY

WOODLAND

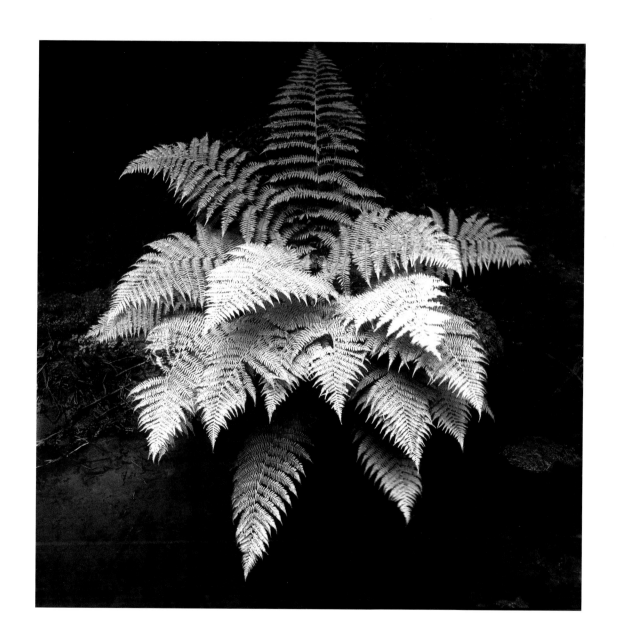

FERN DETAIL, LOCH LOMOND WOODLANDS

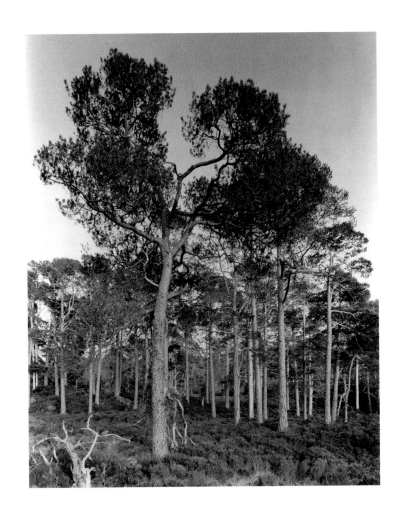

CALEDONIAN PINEWOODS, GLEN AFFRIC

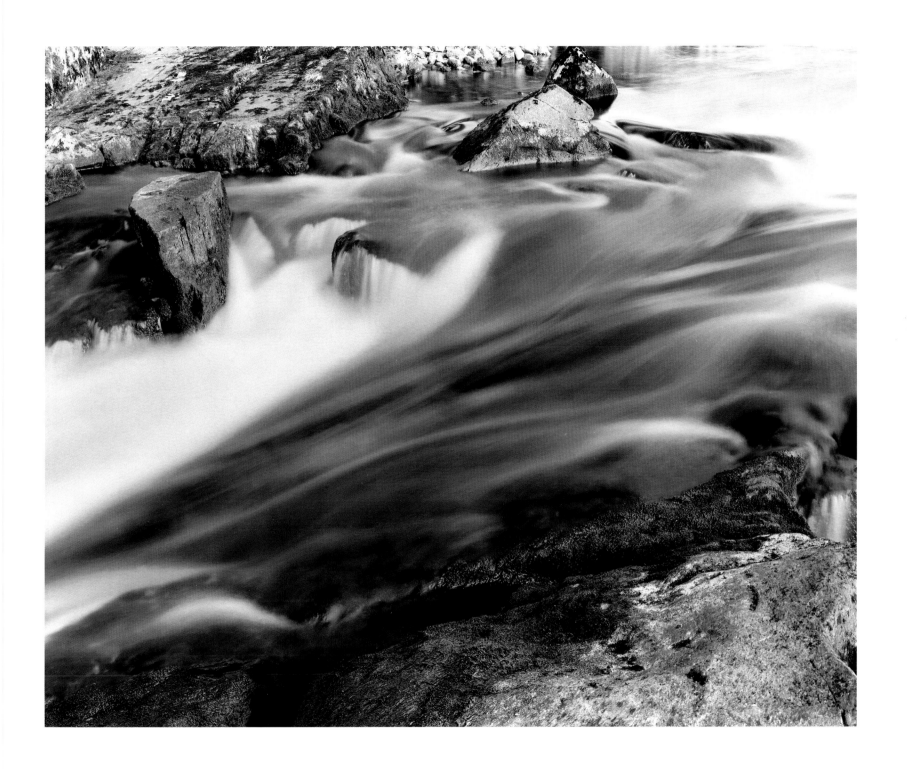

WATER DETAIL, PERTHSHIRE WOODLANDS

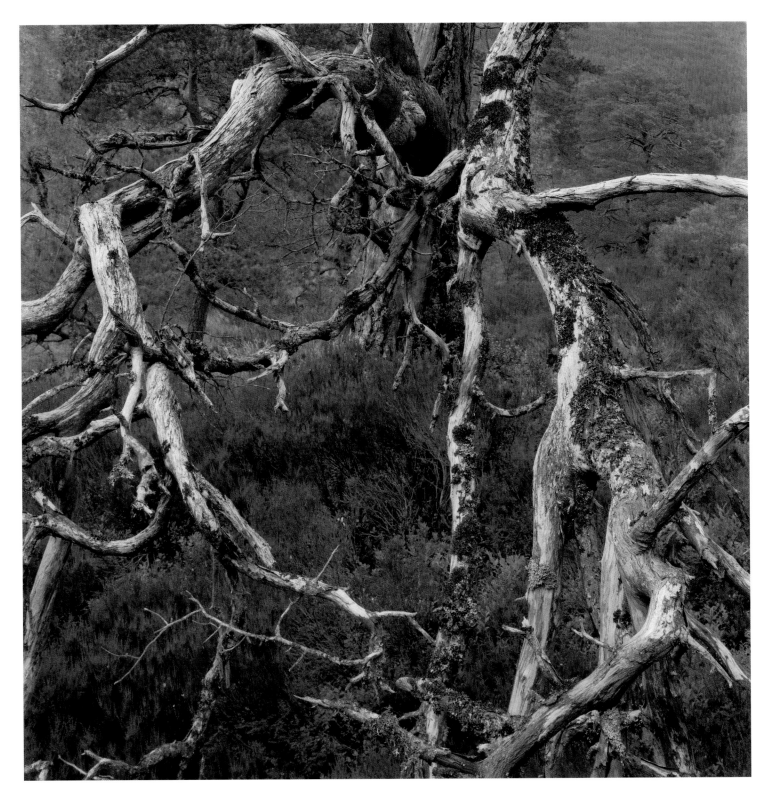

FALLEN TREE, GLEN AFFRIC

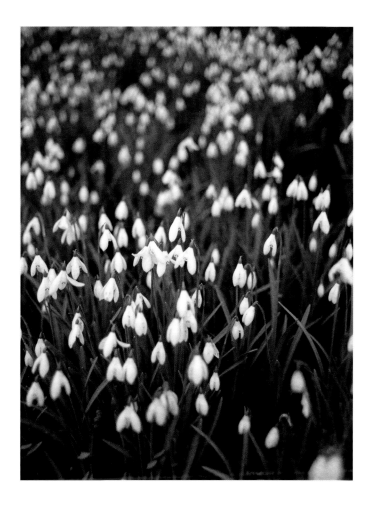

SNOWDROPS ON THE FOREST FLOOR, AYRSHIRE

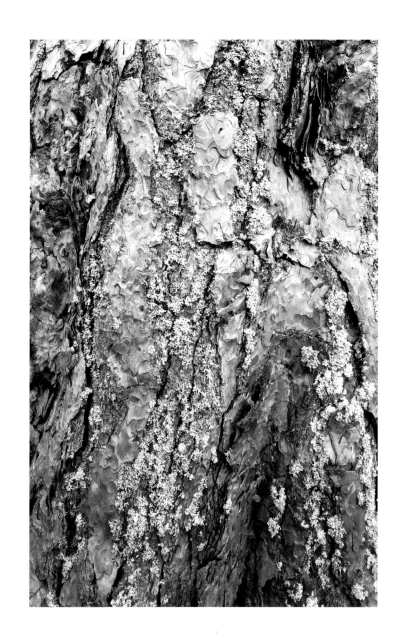

TREE BARK DETAIL, ROTHIEMURCHUS

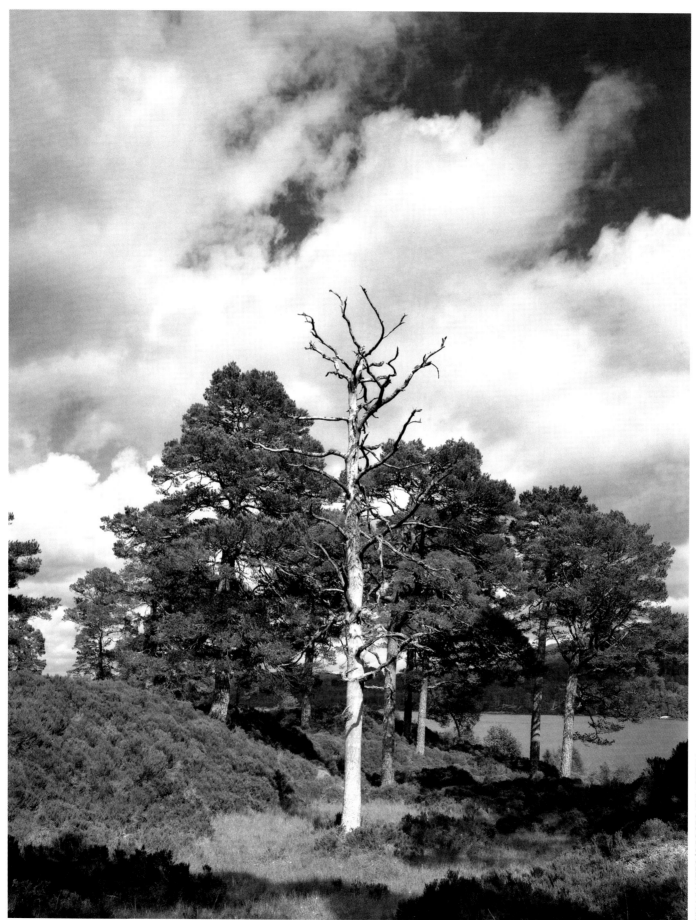

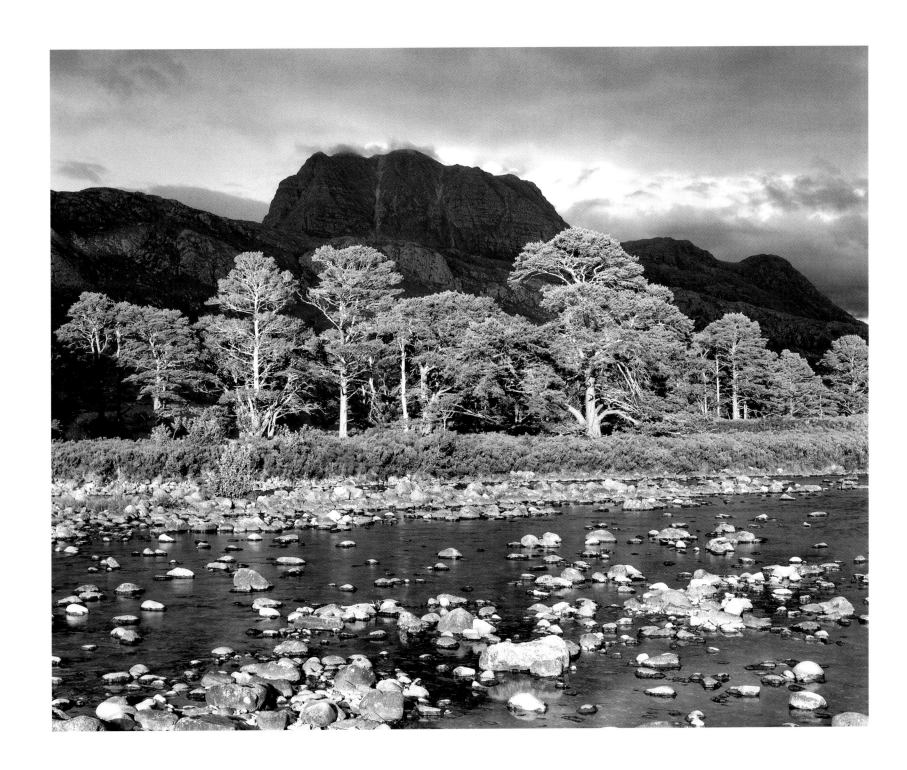

CALEDONIAN PINE WOODS, RIVER KINLOCHEWE

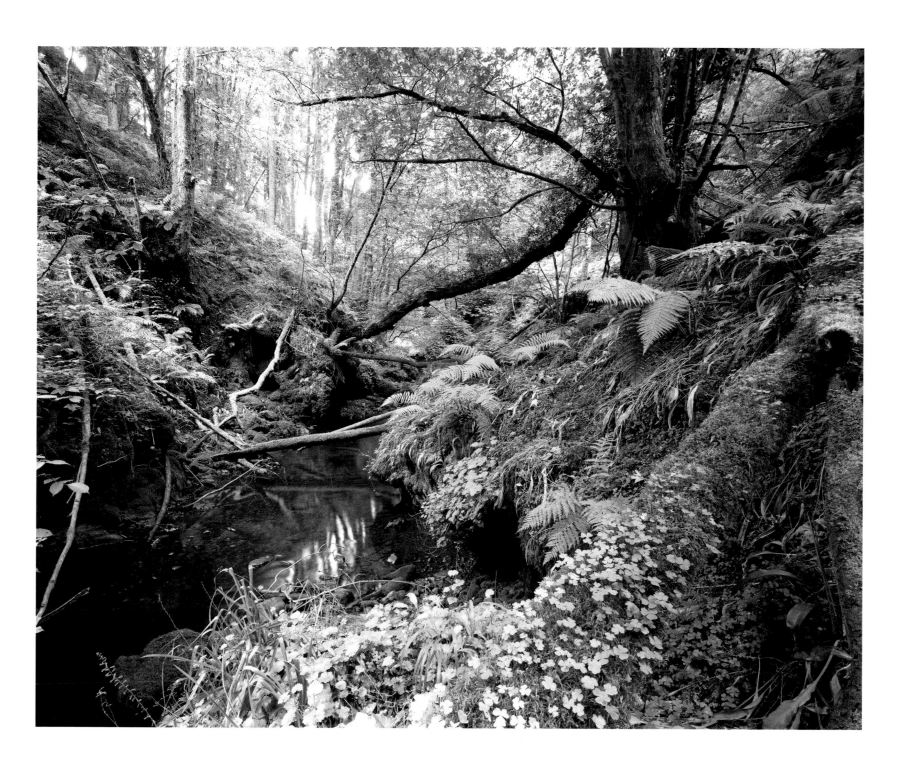

THE INVERKIP BURN, GREENOCK

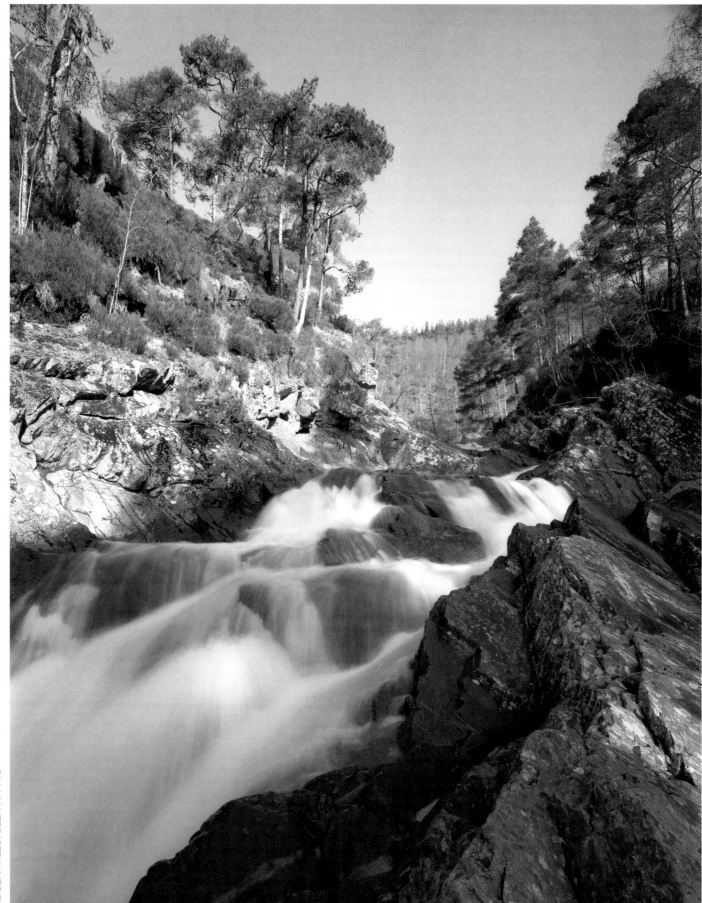

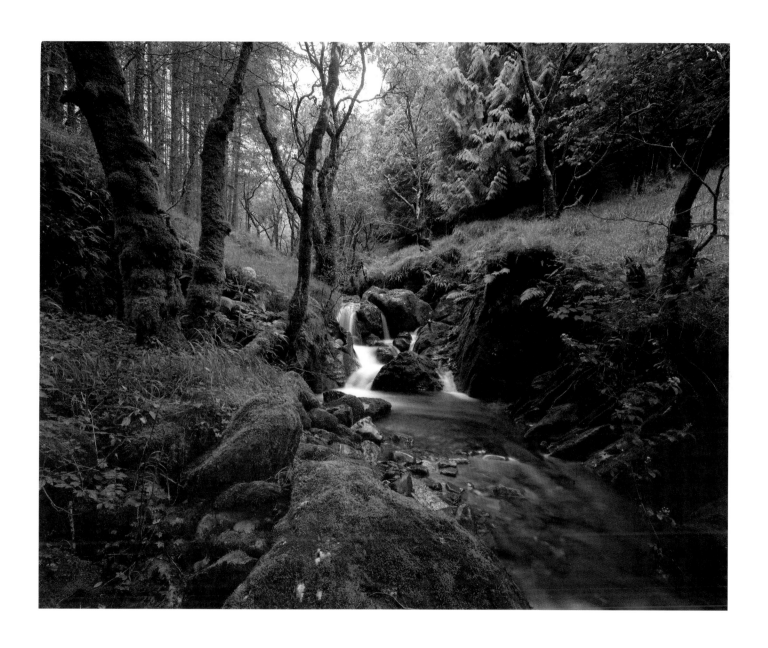

FOREST STUDY, BALLACHULISH

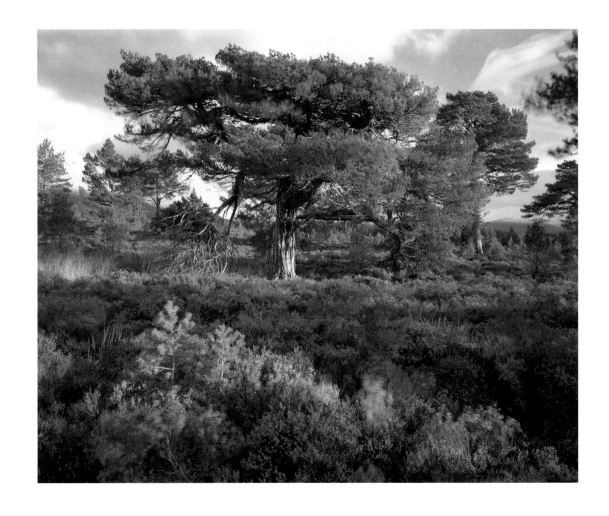

WIND BLOWN PINE TREE, ROTHIEMURCHUS

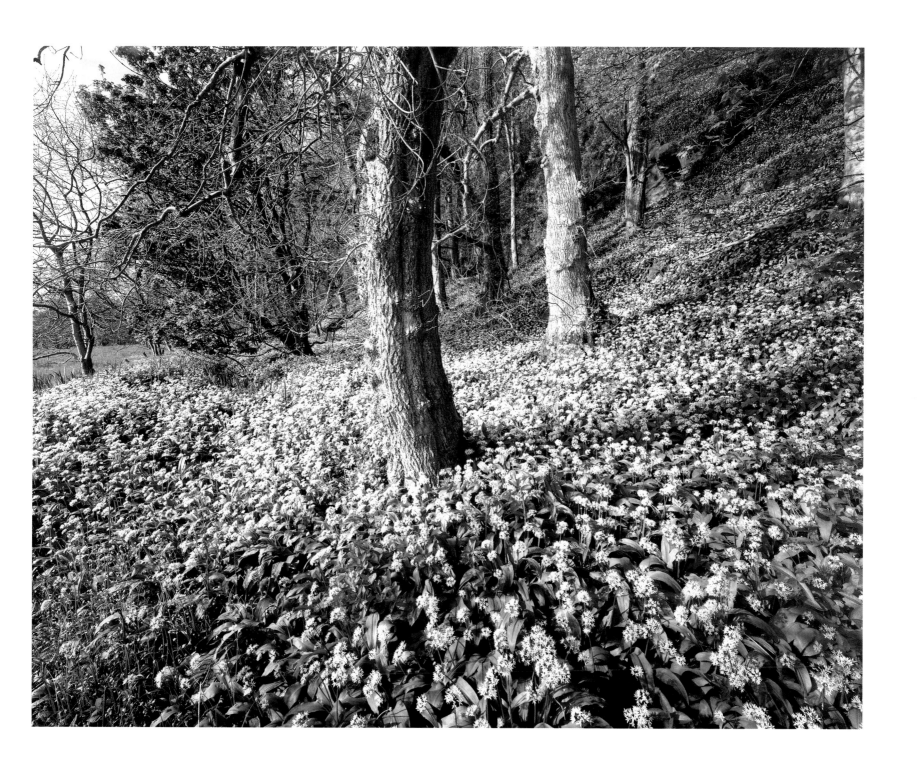

WILD GARLIC, CLYDE COAST

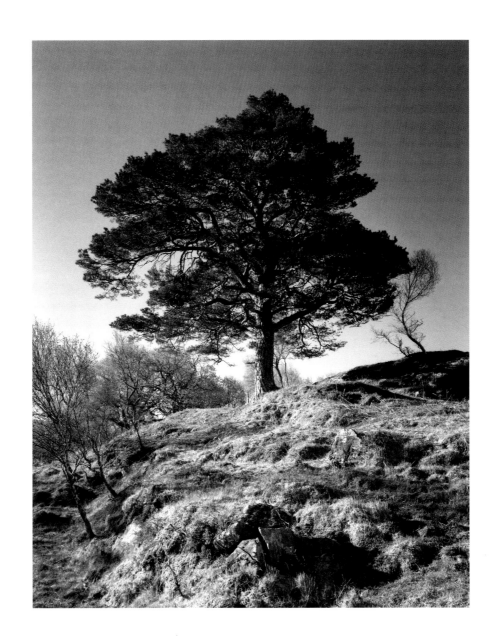

LONE PINE TREE, MOIDART

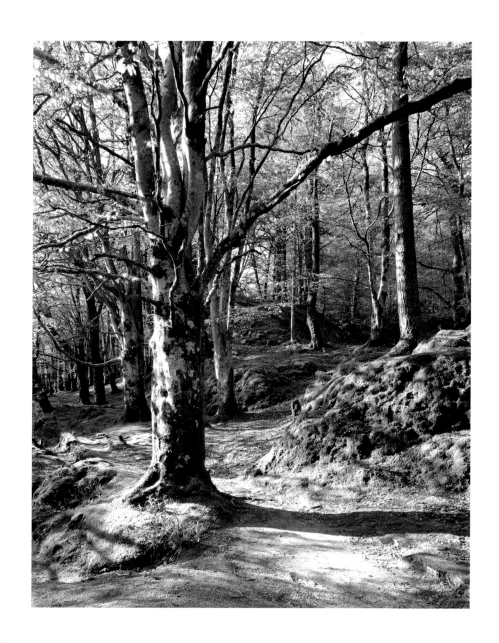

OAK FOREST, GLENCOE

INDEX OF PHOTOGRAPHS

ORIGINAL PHOTOGRAPHS, POSTERS AND CALENDARS ARE AVAILABLE FROM CRAIG MCMASTER PHOTOGRAPHY

www.craigmcmaster.co.uk

ACKNOWLEDGEMENTS

The constant support and encouragement from my wife Tracey throughout this
project has been invaluable. This book and collection of images would not
exist if not for her help; for this I am forever grateful. I also thank my mother who
bought me my first camera many years ago—even though I knew she
could barely afford it. Her gentle and caring support has been a constant inspiration.
My thanks also go to Laird, Ken and Margaret for helping
me on my way.

The contributions to this book from George Wyllie and Alison McGachy (John Muir
Trust) are greatly appreciated. Thank you also to Nicky Golding and Jamie Grant
at WWF (Scotland). Thanks to Andy Green for years of fine printing, guidance and
philosophical discussions. Thanks to Andrew Valentine (The Black Art) and Brian
Errington for years of accurate film processing and fine printing.

Finally, I wish to thank Mercat Press for their enthusiasm and support in making my
vision for this book become a reality.

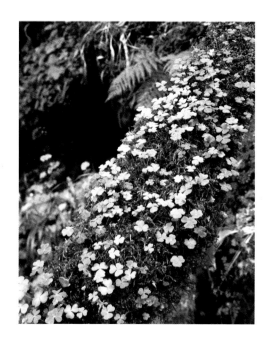

First published in 2004 by Mercat Press Ltd,
10 Coates Crescent, Edinburgh, EH3 7AL www.mercatpress.com

ISBN: 184183 0690

Published in association with the John Muir Trust

Designed by Catherine Read

Printed through Worldprint, Hong Kong